動物嘉年華

西西的動物詩

Carnival of Animals

Xi Xi's Animal Poems

動物嘉年華

西西的動物詩

Carnival of Animals

Xi Xi's Animal Poems

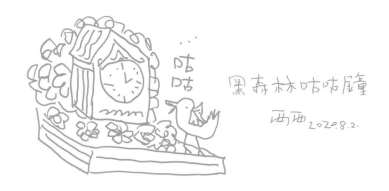

黑森林咕咕鐘
西西 2020.8.2.

西西 著

何福仁 編　費正華 譯

By Xi Xi

Edited by Ho Fuk-yan　Translated by Jennifer Feeley

《動物嘉年華：西西的動物詩》

西西　著
何福仁　編
費正華　譯

國際統一書號 (ISBN)：978-988-237-265-8

2022 年第一版
2023 年第二次印刷

出版：香港中文大學出版社
　　　香港 新界 沙田 · 香港中文大學
　　　傳真：+852 2603 7355
　　　電郵：cup@cuhk.edu.hk
　　　網址：cup.cuhk.edu.hk

Carnival of Animals: Xi Xi's Animal Poems
　　By Xi Xi
　　Edited by Ho Fuk-yan
　　Translated by Jennifer Feeley

ISBN: 978-988-237-265-8

First edition　　2022
Second printing　2023

Published by The Chinese University of Hong Kong Press
　　　　The Chinese University of Hong Kong
　　　　Sha Tin, N.T., Hong Kong
　　　　Fax: +852 2603 7355
　　　　Email: cup@cuhk.edu.hk
　　　　Website: cup.cuhk.edu.hk

Printed in Hong Kong

Supported by

香港藝術發展局全力支持藝術表達自由，本計劃內容並不反映本局意見。
Hong Kong Arts Development Council fully supports freedom of artistic expression.
The views and opinions expressed in this project do not represent the stand of the Council.

目錄
Contents

前言／何福仁　　　　　　7　　　Preface to *Carnival of Animals* / Ho Fuk-yan

譯者鳴謝　　　　　　　　11　　Translator's Acknowledgements

失去猛獁象的語言　　　　14　　The Lost Language of the Mammoth

大公雞　　　　　　　　　16　　The Large Rooster

壁虎　　　　　　　　　　18　　The Gecko

長臂猿　　　　　　　　　20　　The Gibbon

可怕的動物　　　　　　　24　　Scary Animals

想像的動物　　　　　　　26　　The Imaginary Animal

牠住在五星級酒店　　　　30　　It Lives in a Five-Star Hotel

羊駝　　　　　　　　　　32　　The Alpaca

朋友的貓　　　　　　　　35　　My Friend's Cat

什麼也不是的動物　　　　36　　The Animal That Wasn't Anything

水母與蛞蝓　　　　　　　38　　The Jellyfish and the Slug

熊出遊　　　　　　　　　40　　A Bear Goes Travelling

我不和你比　　　　　　　42　　I Won't Compete with You

暖巢　　　　　　　　　　44　　Warm Nest

狒狒　　　　　　　　　　48　　The Baboon

懶猴　　　　　　　　　　50　　The Slow Loris

故宮貓保安　　　　　　　54　　The Forbidden City Security Guard Cat

故宮貓看星　　　　　　　56　　The Cat in the Forbidden City Gazes at Stars

北極熊　　　　　　　　　58　　The Polar Bear

金絲猴　　　　　　　　　60　　The Golden Snub-Nosed Monkey

美麗的動物　　　　　　　62　　Beautiful Animals

貓會生氣　　　　　　　　64　　The Cat Would Be Angry

動物嘉年華　　　　　　　66　　Carnival of Animals

譯者注釋　　　　　　　　79　　Translator's Notes

插畫師簡介　　　　　　　81　　Illustrators' Bios

前言 / 何福仁

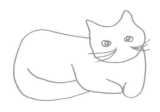

這書是從西西近年的新作中選出，以動物為母題，包括羊駝、猛獁象、猩猩、長臂猿、北極熊，等等，彷彿各種動物在自由園裏舉行嘉年華，是奇書《縫熊志》、《猿猴志》之後，另一種用詩的形式抒寫動物。

詩共23首，難得的是27位繪者參加盛會，有的屬專業，也有的為素人，真是少長咸集，大家平起平坐，為每首詩配以一幅以至多幅繪畫，不拘一格，多元異質。看西西的詩，看畫者的詮釋，加上讀者自己的想像與理解，眾聲複調，文學藝術合該這般如此。

西西向以小說著名，論者認為其特色是變化瑰奇，往往一篇一貌。她的詩，其實也別樹一幟，且是最早結緣。她在中學時代的作品是詩；她也曾任報刊的詩頁編輯，因為太多晦澀的來稿，她自稱看不懂而離任。換言之，早在上世紀六十年代，那是臺港現代詩最晦澀的時期，她對詩已有自己的看法，有自己的詩觀，並且半世紀以來一以貫之，她並不侈言什麼生活化，她的詩根本就是生活的反映，明朗、親切、幽默，不雕詞琢句，不尚虛玄。博爾赫斯曾在《另一個、同一樣》中的序言自剖：

作家的際遇很奇特。開初是巴羅克式，矯飾的巴羅克式，許多年後，要是星運亨通的話，成就的不是簡練，簡練不算什麼，而是適度而含蓄的複雜性。

大可借來說西西，只不過她似乎從未經歷巴羅克式文風。她的詩，沖淡而雋永，言語樸實，卻又充滿奇思妙想。本書23首詩，分別創作，合而觀之，可是互相呼應，既自省人這動物與其他動物的關係，又為弱者發聲，體現一種民胞物與之情，溫暖、關懷，跟異類通靈。

至於美術，我們知道這是她的另一鍾愛，她最初發表的新詩，往往附上自己的繪畫或者木刻，後來在報上連載小說，例如《我城》、《飛氈》，也自行插圖。多年來她一直想出一本繪本，當她知道這次有二三十位畫家主動跟她合作，替她的詩繪畫，她非常高興，說比自己一個人繪畫「更好」。

這書中英對照，感謝費正華的翻譯，她曾譯西西的詩集，名為 *Not Written Words*（《不是文字》），曾因此得翻譯獎。也感謝香港中文大學出版社願意承擔這麼漂亮的一本書，其中彭騰女士費神編務，不勝銘感。

Preface to *Carnival of Animals* / Ho Fuk-yan

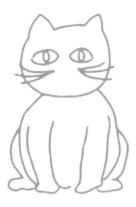

This book showcases a selection of Xi Xi's new works written during the past few years that feature animals as their subject matter, including alpacas, mammoths, orangutans, gibbons, and polar bears—it's as though various animals are holding a carnival in Freedom Park. Following in the footsteps of her unique books *The Teddy Bear Chronicles* and *Chronicles of Apes and Monkeys*, this collection demonstrates another way of describing animals, this time using poetry.

There are twenty-three poems in total. In a rare feat, twenty-seven illustrators have participated in this endeavour; some are professional artists, and some are novices, encompassing a range of experiences and ages, coming together on equal footing, each poem accompanied by at least one illustration, not limited to any form, presenting multiple heterogeneities. Reading Xi Xi's poetry and seeing the artists' interpretations, coupled with the reader's own imagination and understanding, results in a polyphony of various voices—this is how literature and art should be.

Xi Xi is renowned for her fiction, which critics say is characterised by its magnificent variations, with each piece having its own distinct style and form. In fact, her poetry is also in a class of its own, and poetry was her first affinity. Her creative output during secondary school was poetry; she also served as the editor of the poetry page of a periodical. After receiving too many obscure contributions that she claims she couldn't understand, she left this position. In other words, as early as the 1960s, when modern poetry in Taiwan and Hong Kong was at its most obscure, she'd already developed her own opinions and views on poetry, which have remained consistent for half a century. She doesn't spout off grandiose claims about everydayness; her poems are simply reflections of life—bright and cheerful, approachable, and humourous, not made up of flowery sentences and phrases, not prizing the illusory and abstruse. In his prologue to *The Other, The Same*, Borges dissects himself as such:

The fate of the writer is peculiar. At first, the writer is baroque, vainly baroque, and after many years can achieve, if the stars are favourable, not simplicity, which is nothing, but instead a modest and secret complexity.

Applying this idea to Xi Xi, she never seems to have dabbled in the baroque. Her poems are light but meaningful, written in plain language yet full of whimsical ideas. The twenty-three poems in this book were written separately, but when viewed together, they resonate with each other, not only inwardly examining the relationship between human animals and other animals, but also giving voice to the weak, embodying the sentiment of "all humans are siblings, and all things are companions," brimming with warmth and compassion, channelling other species.

As for art, we know it's another passion of hers. Her first published poems were often accompanied by her own drawings or woodcuts. Later, her novels that were serialised in newspapers, such as *My City* and *Flying Carpet*, also included her own illustrations. For several years, she'd been thinking of putting out a picture book, and upon learning that more than twenty artists had offered to collaborate with her on an illustrated poetry book, she was delighted, saying it was "better" than her doing the illustrations alone.

This is a bilingual book in both Chinese and English. Thank you to Jennifer Feeley for her English translation. She won a literary translation prize for her previous translated collection of Xi Xi's poetry, *Not Written Words*. I would also like to thank The Chinese University of Hong Kong Press for being willing to put forth the effort to produce such a beautiful book. In particular, I am deeply grateful to Ms. Rachel Pang for taking such great pains in editing it.

譯者鳴謝

感謝楊維、黃怡和何福仁不吝解答我無數關於動物詩的問題，他們與我一樣，熱愛關於西西的一切。我也感激在推特回應我有關詩內文字遊戲的同仁，尤其是程異、王藝霖、喬海霖、黃運特、陳思可和賀麥曉，他們的建議都體現在書中了。非常感謝香港中文大學出版社的彭騰和編輯團隊的耐性、孜孜不倦的工作和靈敏的眼光。最後，感謝西西多年來的友誼和支持，還有信任，把她自己寶貴的文字交託給我。

Translator's Acknowledgements

I am grateful to Wei Yang Menkus, Wong Yi, and Ho Fuk-yan for generously fielding my numerous questions about these poems and sharing my love and enthusiasm of all things Xi Xi. I also appreciate the feedback I've received from various Twitter colleagues on rendering the wordplay in some of these poems, especially Jeremy Tiang, Yilin Wang, Coraline Jortay, Yunte Huang, Natascha Bruce, and Michel Hockx, whose suggestions have found their way into this book. Many thanks to Rachel Pang and the editorial team at The Chinese University of Hong Kong Press for their patience, tireless work, and keen insights. Finally, I am indebted to Xi Xi for many years of friendship and support, and for trusting me with her precious words.

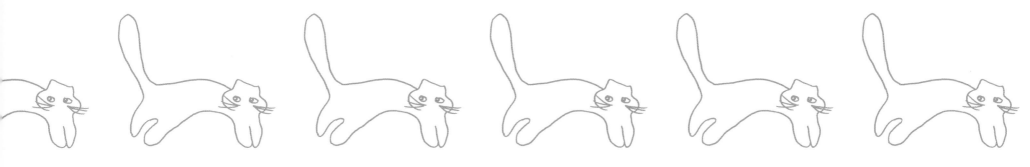

動物詩
Animal Poems

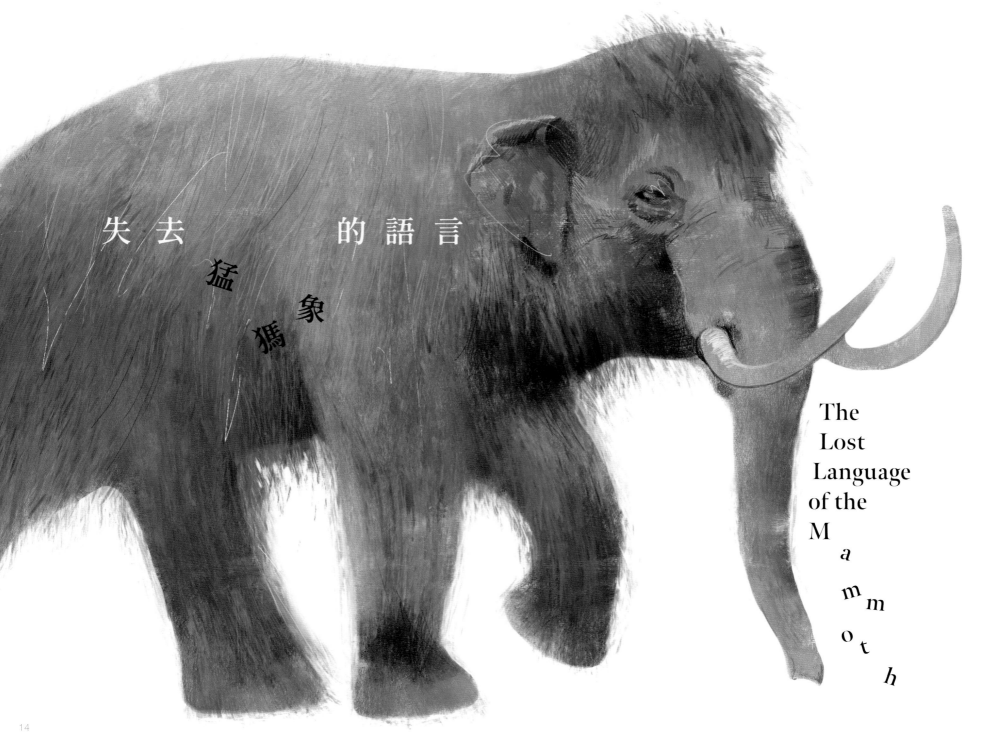

失去 的語言

猛獁象

The
Lost
Language
of the
M
a
m
m
o
t
h

在絕滅之前
猛獁象的孤寂
有五百萬年
當牠說話
誰也不懂得牠
最後，連牠自己也失去了
語言的能力

我們可以複製牠
食物不是難事
不過是草葉、樹皮
不妨加上各種
好味道的營養素
牠可以存活
活在保護區裏
活得很好
讓大家觀看
讓孩童認識一點歷史

但能夠復活牠的語言嗎？
是否有些語言的碎片
留存在冰雪裏？
呵呵，別融化才好
那是牠的記憶
那承載了
牠整個家族的文化

一億年後
當人類滅絕
是否也有些語言
繪畫，或者雕刻，留存
在岩壁裏，在廢墟
尋找其他族類
明白我們的過去

Before it went extinct
The mammoth had been lonely
For five million years
When it spoke
No one understood a word
In the end, it even lost its own
Language ability

We can reproduce it
Food won't be an issue
It's nothing more than grass and bark
Might as well add various kinds of
Tasty nutrients
It can survive
Living in a sanctuary
Where it can thrive
For everyone to see
Giving children a glimpse of history

But can its language be revived?
Are there any language fragments
Preserved in ice and snow?
Oh oh, they better not melt
Those are its memories
Conveying
Its entire family's culture

One hundred million years later
When humans are extinct
Will there be any languages
Paintings, or carvings preserved
In rocks, in ruins
In search of other species
To understand our past?

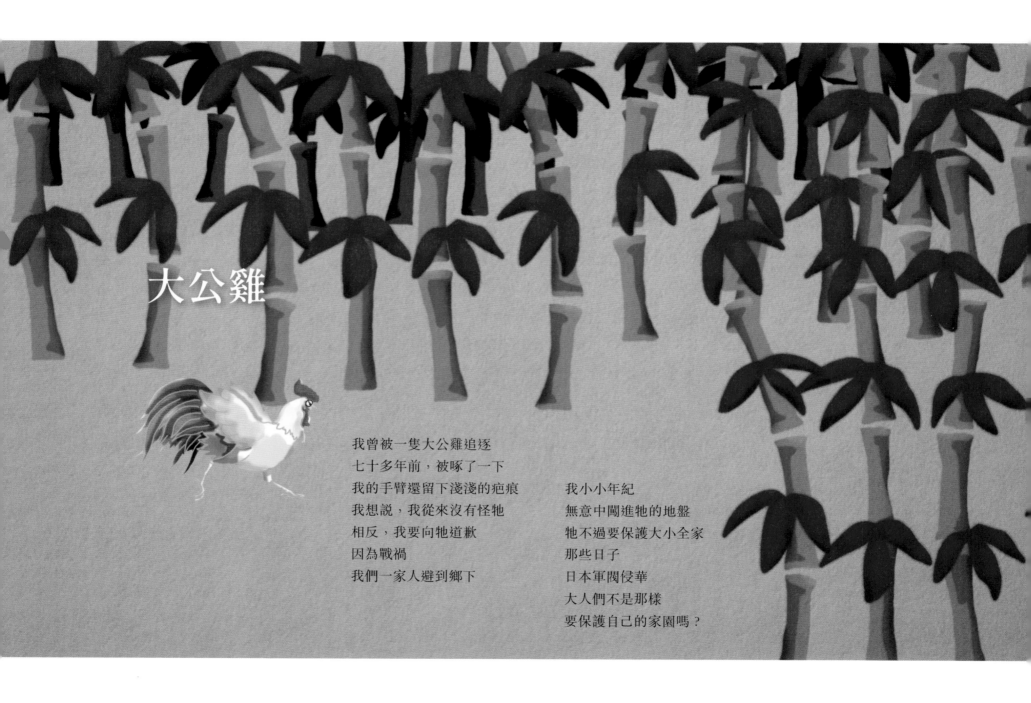

大公雞

我曾被一隻大公雞追逐
七十多年前，被啄了一下
我的手臂還留下淺淺的疤痕
我想說，我從來沒有怪牠
相反，我要向牠道歉
因為戰禍
我們一家人避到鄉下

我小小年紀
無意中闖進牠的地盤
牠不過要保護大小全家
那些日子
日本軍閥侵華
大人們不是那樣
要保護自己的家園嗎？

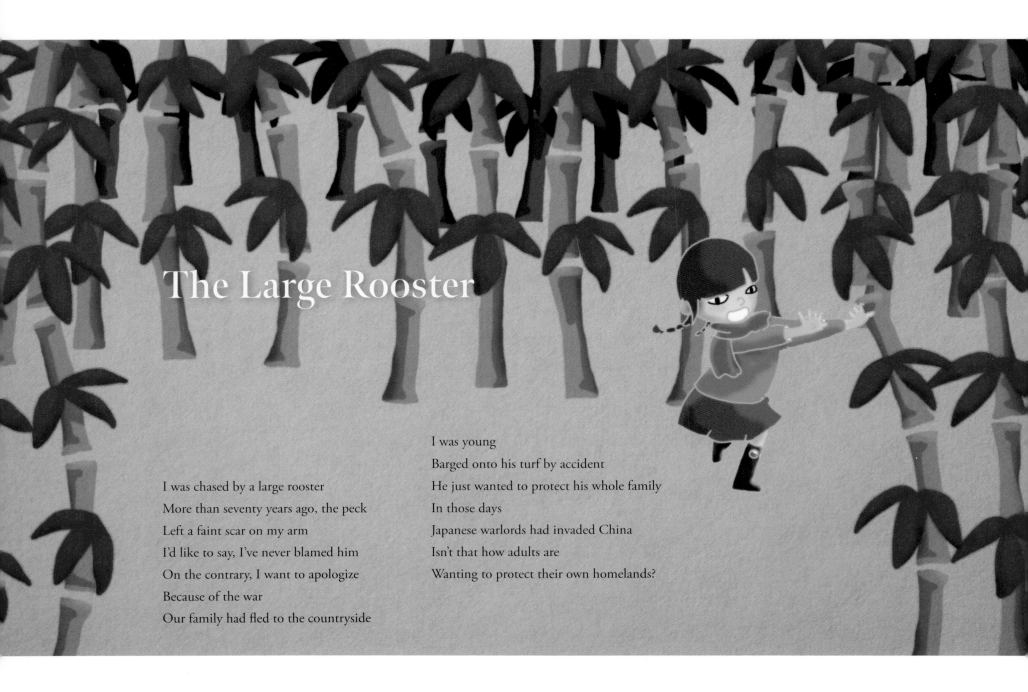

The Large Rooster

I was chased by a large rooster
More than seventy years ago, the peck
Left a faint scar on my arm
I'd like to say, I've never blamed him
On the contrary, I want to apologize
Because of the war
Our family had fled to the countryside

I was young
Barged onto his turf by accident
He just wanted to protect his whole family
In those days
Japanese warlords had invaded China
Isn't that how adults are
Wanting to protect their own homelands?

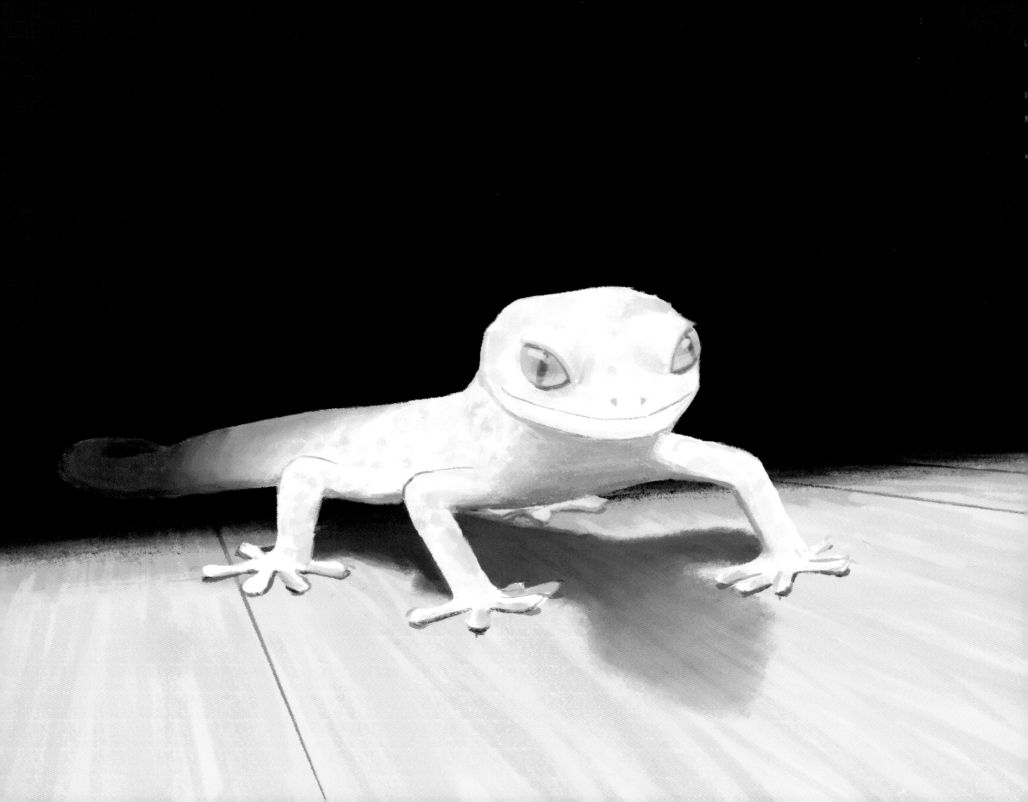

壁虎

啪的一聲響
忽然滿室明亮
在我的面前出現
巨大的人形
兩隻閃爍的眼睛
和我對望

我們都靜止不動
整一二分鐘
敵不動，我不動
這人比我大一千倍
但何必輕易投降
我可以隨時甩掉尾巴
竄到暗角

啪的一聲響
室內又漆黑一片
巨大的黑影
緩緩後退，消失了

聽見一個聲音說：
有條白色的壁虎
難怪家中沒有蚊蠅
我仔細端詳，牠原來
　　很神武

The Gecko

A loud clap
In a snap bright light fills the room
A gigantic human form
Appears before me
Two twinkling eyes
Meet my gaze

Neither of us moves
For a minute or two
The enemy doesn't move, I don't
　　move
This human is a thousand times
　　bigger than me
But why give up so easily
I can drop my tail whenever I need
Flee to a dark corner

A loud clap
The room pitch-black once more
The gigantic shadow
Slowly backs away, vanishing

I hear a voice say:
There's a white gecko
No wonder there aren't any
　　mosquitoes or flies inside
I've studied it carefully—how valiant
　　it turns out to be

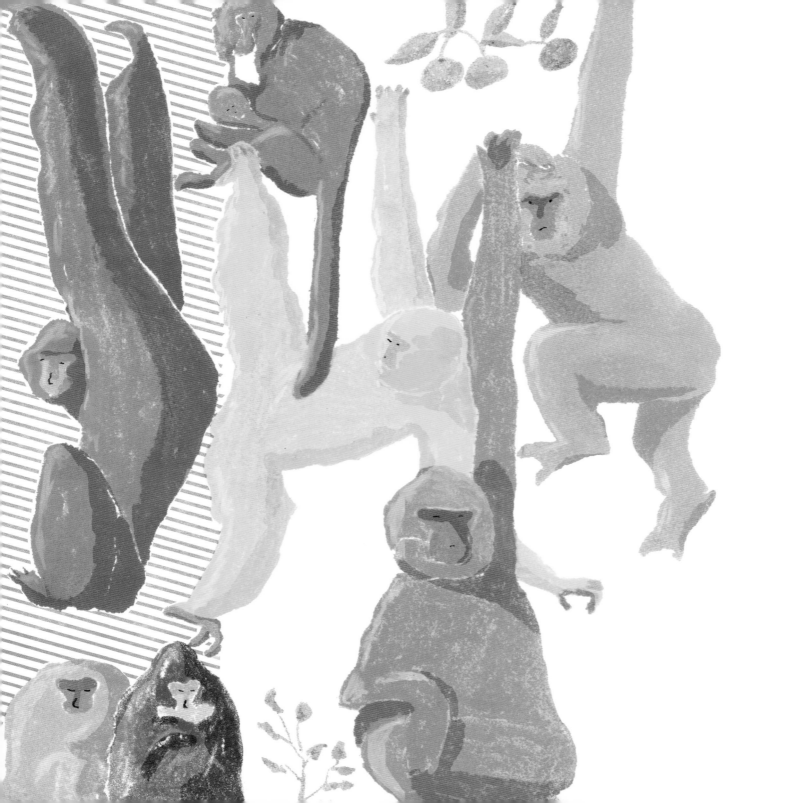

長 臂 猿

The Gibbon

非常矛盾。總是想去看你
又不想看到你生活在
那樣狹窄的鐵籠內
地上沒有一條青草
頭上沒有一片綠葉
名叫動植物公園的公園
對於你們，何嘗有
山林的氣息

沒見你又過了一些日子
你是一歲一歲地長大
還是當年的金髮少年嗎？
我可是老去了，一年會變五年
上次見你時，你的鄰居
搖擺起環尾，在樹枝上舞蹈
紅毛猩猩在架空隧道中穿行
都不再出現？

我已經多次呼籲，希望
在你們的籠頂上蓋
搭一層明瓦，鋪一層樹葉
讓烈日不會灼傷你們
籠內的石灰地面散置枯木
讓你們有些停歇的驛站
但我人微言輕
哪有人聽得見？

隔岸罷了，似近
還遠，閉目仍憶起
你與雙親在鐵絲網上的姿態
一家三口，不同的毛色
那樣地飛騰，那樣地回旋
像盪鞦韆，左手換右手
右手換左手，再穩健地
降落網架上

我記得多年前在長江三峽旅行
聽過你的前輩的歌聲
遼遠，高妙，此唱彼和
唱活了空靈的畫面
失去了，大地會多麼寂寥
你們本是隱者終生
和伴侶生活於幽谷
帝力無擾

一年又過去如今你我
分隔兩岸，中間一個海港
逐漸也陌生起來
林立的是高樓，想見你已微茫
力不從心哪，親愛的長臂猿
你還安好嗎？等一個風和日麗
平安的日子，再上公園看你
我也嘗試運走回旋，在輪椅上

The Gibbon

I'm torn. I always want to see you
But I don't want to see you living
In such a cramped metal cage
Not a single blade of grass on the ground
Not a single leaf of green on your head
For you, how could
A park called the Zoological and Botanical Gardens
Compare to the air of a mountain forest

I haven't seen you in a while
Have you grown up year by year
Or are you still the fair-haired youth you were back then?
I'm getting old—one year turns into five
The last time I saw you, your neighbour
Wagged its ringed tail, danced on tree branches
Is the orangutan who passed through overhead tunnels
No longer there?

I've made several appeals, hoping
For the top of your cage to be shaded
Laid with transparent tiles, spread with tree leaves
So that the scorching sun won't burn you
For dead wood to be strewn on the concrete floor inside
So that you'll have some resting stations
But my humble words carry little weight
Can anyone hear me?

You're just on the other side, seemingly near
Yet so far away, closing my eyes I still recall
The stance of you and your parents on a chain-link fence
A family of three, with coats of different colours
Soaring, whirling
As if playing on a swing, left hand then right hand
Right hand then left hand, steadily
Landing on each grid

I remember travelling along the Three Gorges of
 the Yangtze many years ago
Hearing the songs of your elders
Far-off and sublime—one would start singing,
 then others would join
Their songs bringing ethereal scenes to life
If lost, how lonely the earth would be
You are hermits your whole lives
Living in valleys with your mates
Undisturbed by imperial power

Another year has passed, now you and I
Are separated on two sides, a harbour in the middle
Becoming less and less familiar
Jungles of high-rises everywhere, my hopes of
 seeing you are slim
Powerless to do as I wish, dear gibbon
Are you safe and sound? On a sunny
Peaceful day, I'll go back to the park
 and see you
I'll also try my hand at whirling around
 in my wheelchair

可怕的動物

我讀到中國一本古書
記載了許多古怪的地方
許多離奇怪誕的動物
在山上，在海裏
樣子恐怖
好像是經過基因變異
會吃人，會作祟
總之大多不是好東西

有這樣的書，或者傳言
我不會感到意外
當是神話，異想天開
也蠻有趣

只不過，要是那地方的動物
同樣也記載了古怪的人類
很醜，還會吃動物
有好人，但壞人更多
只會在地上兩條腿行走
但運用機械
捕殺了我們許多的同類
呵，多麼可怕的人類

是的，當我們審判異類
難保異類不會也審判我們
從對方看來，我們何嘗不是
　異類
當我們拒絕不同的話語
不同的思維
我們就成為妖怪
沒有耳朵、眼睛
沒有腦袋

Scary Animals

I read an ancient Chinese book
That records many strange places
Many weird and freakish animals
On mountains, in seas
Dreadful-looking
As though genetically mutated
Eating people, making mischief
In sum, most of them up to no
　good

That there's such a book, such
　rumours
Doesn't surprise me
If I consider it a myth, letting my
　imagination run wild
It's really quite entertaining

But what if the animals in those places
Also record strange humans
Who are ugly and eat animals
Though there are good people, there
　are more who are bad
They can only walk on two legs
But use machinery
To catch and kill many of our own
　kind
Oh, what scary humans

Yes, when we judge others
There's no guarantee they won't judge
　us back
From their viewpoint, are we not the
　other kind
When we reject different words
Different ways of thinking
We turn into monsters
Without ears or eyes
Without a brain

想像的動物

牠沒有一張罵人的嘴巴
並不表示牠不會分辨是非
不過高興的時候，老遠的地方
也會聽到牠嘹亮的歌聲

牠前後有四隻眼睛
可以同時看到前後方
看到不同的風景
我們人類總看不見後面

耳朵兩隻，夠了
只是不要一邊入，另一邊出
不用聽太多閒言閒語
聽長輩的故事、教訓
還是有益的

牠不需衣服
但毛色會隨季節變換
變什麼都好，只要牠喜歡
牠有時會對着一朵花出神
嗅着老半天

牠有一個很大很大的胸腔
裝了一個很大很大的心臟
也可能因為這個緣故
即使牠垂下兩手
成為四隻腿腳，還是
跑得不夠快

牠也需要睡眠
睡在樹上，山洞裏
必要時，睡在水裏
只要安全

牠素食
牠並不笨
就是不會計算

牠只是我想像中的動物
我沒有把牠想像成天下無敵
百毒不侵，可這麼一來
離地太遠
還有什麼意思呢
但我的確想得並不透徹
因為我還沒有想到
牠在難以想像的世界裏
可以怎樣生存

The Imaginary Animal

Just because it doesn't bad-mouth anyone
Doesn't mean it can't tell right from wrong
But when it's happy, even from far away
You can hear its loud and clear song

With four eyes in front and back
It can see in both directions at the same time
Taking in different scenes
We humans can't ever see what's behind

Two ears are enough
Just don't flow in one and out the other
No need to pay attention to too much idle gossip
Heeding the stories and lessons of elders
Still has its benefits

It doesn't need clothes
But its coat colour changes with the seasons
It can become whatever it likes
Sometimes it falls under a flower's spell
Breathing its scent all day long

It has a big, big chest
With a big, big heart
That might be why
Even if it drops its hands
Giving it four legs, it still
Can't run fast enough

It also needs sleep
It sleeps in trees, in caves
If needed, it sleeps in water
As long as it's safe

It doesn't eat meat
It's by no means stupid
It just doesn't know how to be calculating

It's only an animal of my imagination
I haven't imagined it to be invincible
Impervious to all poisons, but then
What's the point in being
Too detached from reality?
I really haven't thought things through
Because I haven't figured out
How it can survive
In a world that's hard to imagine

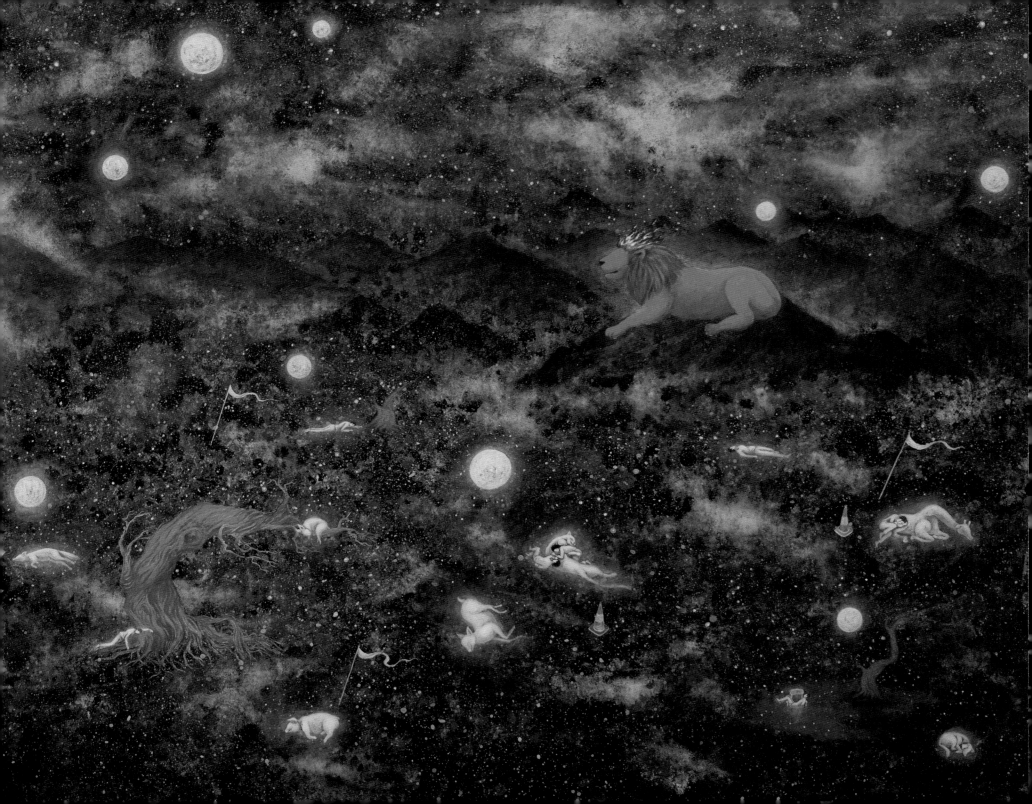

牠住在五星級酒店　　　　It Lives in a Five-Star Hotel

牠住在獅子頭上一大把鬃毛裏
牠很滿意，那是五星級酒店
而且可以享受
經常變換的
無敵風景

當獅子大口大口的吃着羚羊
七八隻禿鷹在一旁吞着口水
等待的是菜餘
牠呢，可以同時享用
客房服務，不用付賬

日落時，獅子向着草原咆哮
所有動物都凝神靜聽
這裏面一定包含了牠的口信
牠覺得自己也很有威嚴

天氣酷熱時
獅子躲在樹蔭下喘息
牠對自己說
有難同當才夠義氣
何況晚上寒冷
可以彼此取暖

一天，一群烏蠅飛來
牠對這群闖客說：
你們飛來飛去，不累麼
看你們多麼不受歡迎
多麼不要臉
大王對你們不住搖頭
要把你們甩掉

烏蠅只聽到聲音
嗓門不小，就是看不見來源
終於看到了
原來是一隻蚤子

It lives in the wild mane of a lion's head
Perfectly content, a five-star hotel
Where it's treated to
Ever-changing
Unmatched views

As the lion devours an antelope
A wake of vultures slurps back drool
Waiting for leftovers
Meanwhile, it enjoys
Room service, free of charge

At sunset, the lion roars toward
　　the plains
All animals listen intently
Its message must be contained inside
It prides itself on being dignified

When it's hot
The lion hides in the shade and pants
It tells itself
That sticking together when times are
　　tough is true loyalty
Besides, on cold nights
They can keep each other warm

One day, a swarm of flies buzzes over
It asks these trespassers:
Aren't you tired of flying to and fro?
Look how unwelcome you are
How shameless
The king shakes his head at you
Casting you off

The flies only hear a sound
The voice is loud, they just can't
　　spot where it's coming from
At last they see
It belongs to a little old flea

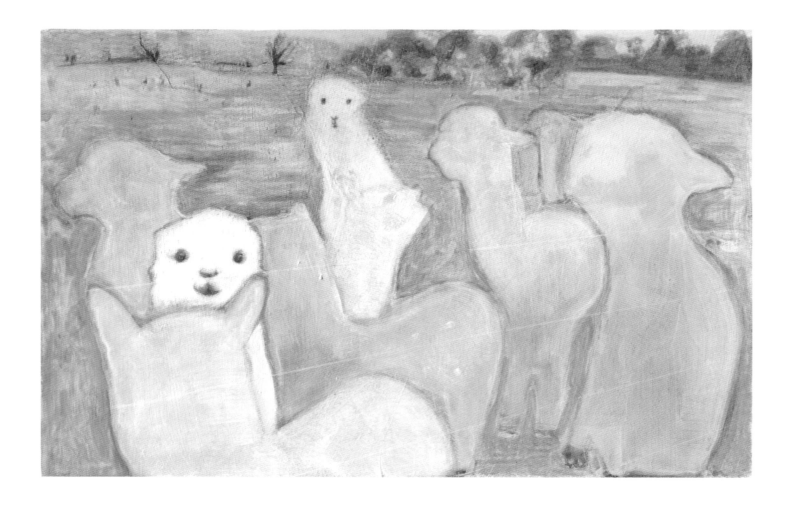

羊駝

我喜歡的動物有很多
有些我見過，有些
只是在書本上，在電視電影裏看到
有什麼關係呢
知道世上有這些可愛的動物
就夠好了
我從未到過南美洲，雖然
我喜歡那裏的作家
我喜歡那裏的一種動物
叫駝羊
到底是駝，還是羊
我不知道，我覺得
不一定要知道才可以喜歡
我還是查了一下

原來我把名字顛倒了
就像習慣把貓熊
倒過來叫熊貓
應該叫羊駝才對
因為屬於駱駝家族
又叫草泥馬
哈哈，又跟馬扯上關係了
牠的樣子有趣
小小的頭，像羊
長長的頸項，當然沒有
長到長頸鹿那樣
但跟身軀同樣非常胖壯
一身絨毛
健碩的腿，可以

走在寒冷的山區
可以快速地奔跑
但有些人以為牠們不成比例
他們的所謂美人
都由尺做評判
那是可怕的對稱
我以為羊駝很漂亮
天生和善、諧趣
而且，最適合牠們生活的地方
是印加帝國的遺產
帝國消失了
牠們留下來
成為人類的朋友
應該受到尊重，獲得善對

The Alpaca

There are many animals I like
Some I've seen with my own eyes, some
Only in books, on TV, in movies
What does it matter?
Knowing these lovely animals are in the world
Is good enough
I've never been to South America, though
I like the writers there
I like an animal there
Called the camelish sheep (pacos lama)
Is it a camel, or is it a sheep?
I don't know, I think
You don't have to know for sure to be fond of it
I've looked it up anyway

Oops, I mixed up the name
Like how I always mix up panda cat
And panda bear
It should be the sheepish camel (lama pacos)
As it belongs to the camel family
It's also known as the muddy llama (bloody mama)
Haha, now we're back to llamas
It has a curious appearance
A small, small head, like a sheep
A long, long neck, of course not
As long as a giraffe's
But a body that's similarly stocky
A fluffy coat all over
Strong legs, able to

Traverse ice-cold mountains
Able to run fast
But some people find them disproportionate
Their so-called beauty ideals
Measured by a ruler
What a terrible symmetry
I think alpacas are beautiful
Inherently kind, and good-humoured
What's more, the best place for them to live
Is the vestiges of the Inca Empire
The empire's long gone
They've stayed behind
Becoming friends of humankind
They deserve respect, to be treated with kindness

朋友的貓 My Friend's Cat

朋友的貓　　　　　　　the erudition of my friend's cat

學問肯定比朋友好　　　is certainly unmatched

朋友的書　　　　　　　when it comes to books

只是讀過　　　　　　　my friend simply looks

牠呢，全部讀破　　　　while the cat is more than up to scratch

什麼也不是的動物

The Animal That Wasn't Anything

有一天，叢林裏最大的一棵
　　麵包樹下
睡着一個動物
發出呼嚕呼嚕的聲響
環尾狐猴問：這是什麼？
不會是猴類吧
樹蛙端詳了好一陣，説：
睡在地上，這不是樹蛙
這樣答，是因為世上有許多
　　許多的動物
到底有多少，誰知道
增多，或者減少
雲豹説：絕對不是雲豹，我肯定
捻角山羊説：山羊？又沒有角
黑臉琵鷺説：沒有翼，不會是鳥
象龜説：也沒有殼，不可能是龜
黑犀牛説：別問我，不會是犀牛
看來，這傢伙也快絕滅了

竹節蟲怯生生，説：不是蟲類
希望，希望這動物，沒有惡意
　　才好
銀背猩猩拍打胸膛，説：
當然不是猩猩，別怕
來了更多的動物
稀有的，倖存的，所餘無幾的
可沒有一種認為這是同類
結果，這動物什麼也不是
大家目定口呆
面面相覷
難道是外星族
是冰川融化後出來
許久，這動物醒轉
打了一個呵欠
吵什麼，你們
連八十億的人類都不認識麼？

One day, beneath the biggest breadfruit tree in the jungle
Some sort of sleeping animal
Released a rumbling snore
The ring-tailed lemur asked: What's this?
It can't be a monkey
The tree frog studied it for a while, then said:
That thing sleeping on the ground isn't a tree frog
It answered this way because there are many, many animals
　　in the world
Just how many are there? Who knows
Are there more or less than before?
The clouded leopard said: It's definitely not a clouded
　　leopard, I'm sure
The markhor said: A goat? It doesn't have horns
The black-faced spoonbill said: It doesn't have wings, it's
　　not a bird
The tortoise said: Nor does it have a shell, it can't be a
　　turtle

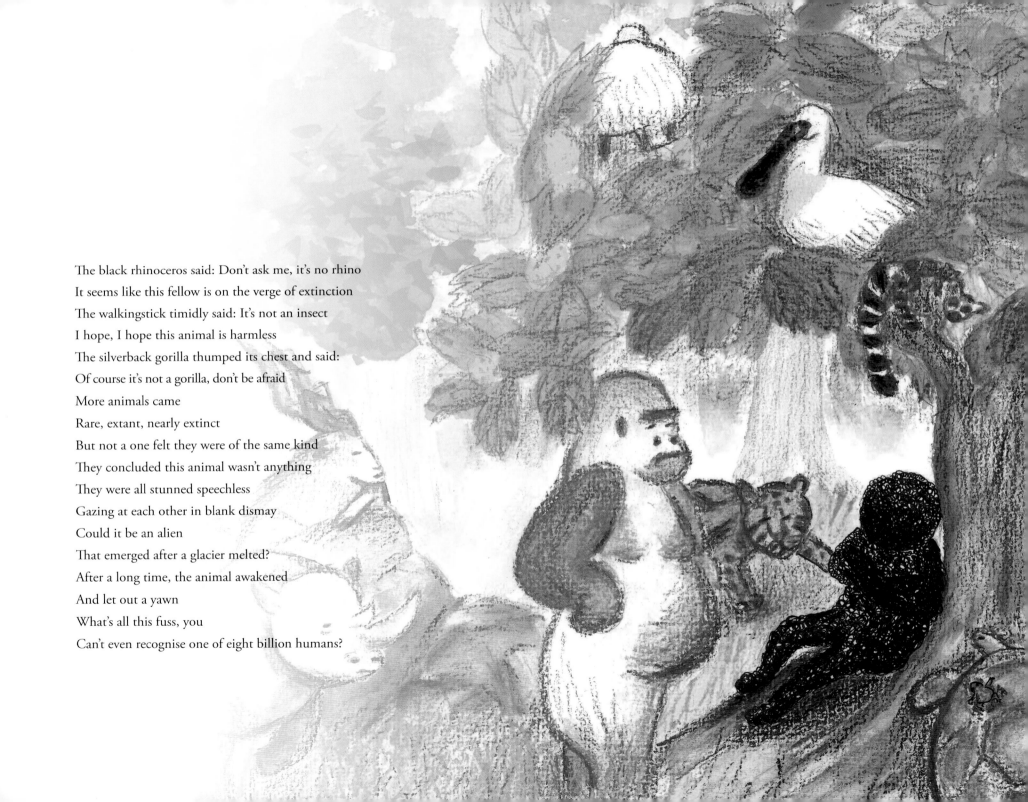

The black rhinoceros said: Don't ask me, it's no rhino
It seems like this fellow is on the verge of extinction
The walkingstick timidly said: It's not an insect
I hope, I hope this animal is harmless
The silverback gorilla thumped its chest and said:
Of course it's not a gorilla, don't be afraid
More animals came
Rare, extant, nearly extinct
But not a one felt they were of the same kind
They concluded this animal wasn't anything
They were all stunned speechless
Gazing at each other in blank dismay
Could it be an alien
That emerged after a glacier melted?
After a long time, the animal awakened
And let out a yawn
What's all this fuss, you
Can't even recognise one of eight billion humans?

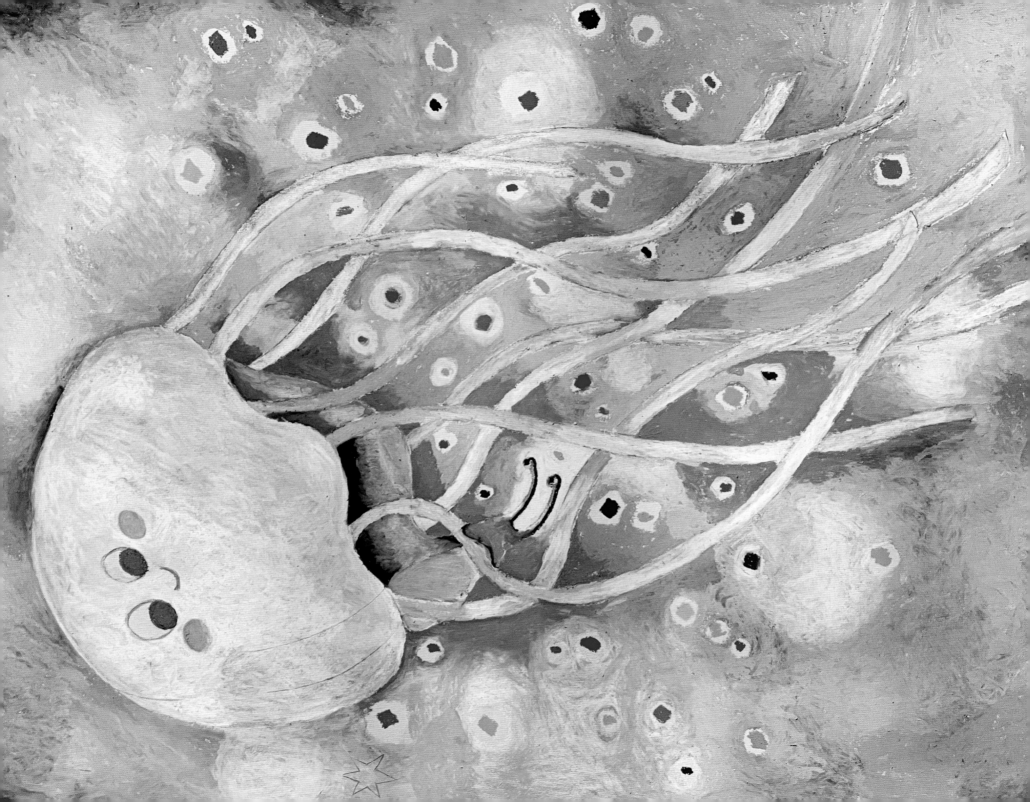

水母與蛞蝓

在拿不勒斯港灣
天空藍，海水暖

蛇髮的水母
打起一頂透明傘
到海洋公園的涼亭用餐
裸鰓的蛞蝓
實在是美味的海鮮

蛞蝓搬進水母的玻璃別墅
躺在紗帳裏
無憂無慮過日子
早餐吃掉水母的輻管
午餐吃掉水母的裙子
晚餐吃掉水母的觸鬚

不消多久
蛇髮的水母
變成汽泡般的小蘑菇
寄生在蛞蝓的唇邊

你中有我
我中有你
依偎共生

天空藍
海水鹹
在維多利亞港灣

The Jellyfish and the Slug

In the Bay of Naples
The sky is blue, the seawater is warm

The medusa
Opens a transparent umbrella
Sets off to dine at a pavilion in Ocean
 Park
The nudibranch slug
Is truly a tasty seafood treat

The slug moves into the jellyfish's
 glass mansion
Kicks back inside the sheer canopy
Without a care in the world
Eats the jellyfish's radial canals for
 breakfast
Eats the jellyfish's skirt for lunch
Eats the jellyfish's tentacles for dinner

In no time
The medusa
Turns into a tiny bubble-like mushroom
A parasite on the lips of the slug

I am in you
You are in me
Snuggled-up symbiosis

The sky is blue
The seawater is salty
In Victoria Harbour

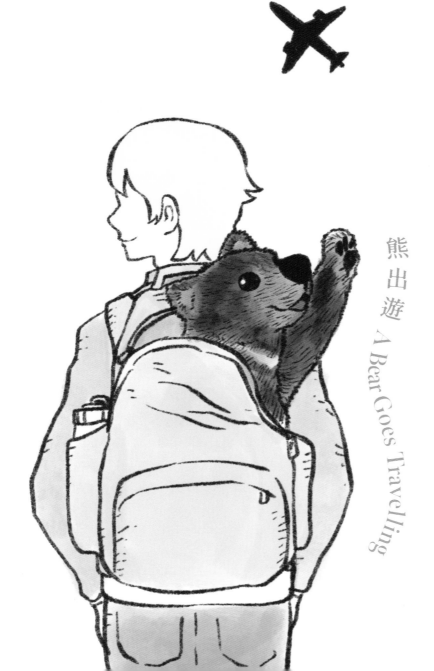

熊出遊 A Bear Goes Travelling

在異國機場內
見到一個年輕男子
背囊的頂端敞開
一隻毛熊伸出頭來
兩顆大眼睛看着我
含蓄地，微笑
說：旅行這樣開始
不是很好麼

我聽得懂牠的語言
即使聽不懂，有什麼關係呢
我也經常帶着小熊旅行
去過不同的地方
看到牠的人都很高興
我想，牠也是高興的
牠如今就坐在窗臺上
看人，看風景

In an airport in a foreign land
I see a young man
The top of his backpack open
A furry bear poking out its head
Two big eyes staring at me
As if to smile
And say: Isn't this a great
Start to a trip?

I understand its language
Even if I didn't, what does it matter?
I've also often taken a small bear on trips
To various places
Everyone who saw it was happy
I think it was also happy
Now it sits on the windowsill
Looking at people, looking at the scenery

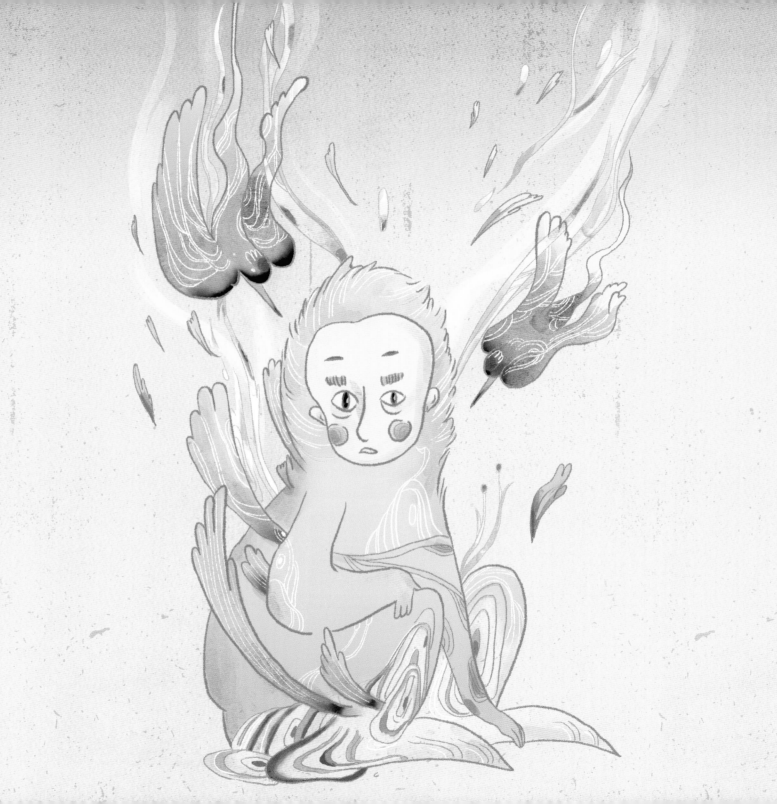

我不和你比

你是獵豹
我是懶猴
我不和你競跑

你是大象
我是金絲猴
我的鼻子不會說謊

你是燕鷗
我是麻雀
不和你比飛行里數

你是兔子
我是烏龜
不和你比睡覺

你會獅子吼
我是雞仔聲
你唱歌劇
我哼小調

你住淺水灣
我住土瓜灣
我不和你比沙灘

你四處演說
我無話可說

你相識遍天下
我朋友只好幾個

但我不羨慕你
你犯不着看我不起

I Won't Compete with You

You're a cheetah
I'm a slow loris
I won't race against you

You're an elephant
I'm a golden snub-nosed monkey
My nose can't tell a lie

You're a seabird
I'm a sparrow
I can't compete when it comes to
 miles flown

You're a hare
I'm a tortoise
I can't compete when it comes to
 sleep

You can roar like a lion
I squawk like a baby chick
You sing opera
I hum a little ditty

You live in Repulse Bay
I live in To Kwa Wan
I can't compete when it comes to
 beaches

You give speeches far and wide
I have nothing to say

You know everyone under the sun
My friends are few in number

But I'm not green with envy
You needn't waste your time
 looking down on me

暖巢

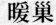

是什麼人，在大廈長廊的
　高簷下
懸掛起一盆奇異的植物
圓圓的容器，邊緣垂下幾條
忽長忽短的枝藤彷彿
童話中美人魚的頭髮

離地六、七米的高度，花盆
仔細地掛在簷沿下的內側
這或許是錯誤的選擇
借來的角落缺乏直照的陽光
又接收不到足夠的雨水
再說，怎麼會把盆栽
擱上一盞夜燈的背脊上？

好幾次在盆栽底下走過
抬頭觀看，總覺不妥
人類何其愚昧，竟將
花草錯置了地方

那植物的葉片越長越長了
在微風中輕輕搖曳着
忽然飄起兩片盤旋而下
互相追逐嬉戲的白色羽毛
啊，我頭頂上的盆栽
原來是個小小的鳥巢

天地間精緻的建築
由小嘴喙耐心地織造
恰恰選在簷下內側的位置
原來為了擋風避雨
遠離獵鷹的目光
它寄託在燈箱之上
每當昏黃的燈色亮起
光引導夜鳥歸航
巢底是雛鳥溫暖的眠床

大廈維修的那段日子裏
簷外搭起了竹棚
我每天在棚架下走過
抬頭仰望，憂心忡忡
如今我們的城市
舊的不斷拆卸改成華廈
樓價不斷上漲
有的，我居住四周的地方
三四十年再翻修
有些拆小變成了劏房
我們就是這樣生活
我多麼想請求
搭棚的師傅
放過這些小小的鄰居吧
即使跟我們不同類
還沒開口，翻修已經完成
高空的鳥巢仍在
保住了

Warm Nest

What person hung a strange potted plant
Beneath the high eaves of the building
 promenade
A round vessel, a few long and short tendrils
Dangling from the edges like
The hair of a fairy-tale mermaid

Six or seven meters above ground, the flowerpot
Carefully tucked beneath the eaves
Perhaps this isn't the best choice
The borrowed corner lacks direct sunlight
And doesn't get enough rain
Besides, why would someone set a potted plant
On the back of a night lamp?

I've walked under the potted plant several times
And glanced up, something always seems off
How foolish people are, putting
Plants in the wrong place

The plant's leaves grow longer and longer
Swaying gently in the breeze
Suddenly two are swept up then whirl down
White feathers chasing and playing with each
 other

Oh, the potted plant above my head
Is in fact a small bird's nest

A delicate structure between heaven and earth
Patiently woven from a tiny beak
Precisely positioned beneath the eaves
Sheltered from wind and rain
Away from the falcon's gaze
Resting on a lamp box
Whenever the faint light turns on
Its beams guide the night bird home
The bottom of the nest a warm bed for its
 offspring

While the building undergoes renovation
Bamboo scaffolding is set up outside the eaves
I walk beneath it every day
And gaze up, heart heavy with worry
Now the old things in our city
Are constantly knocked down, replaced with
 luxury high-rises
Property prices skyrocketing
Some places in my neighbourhood
Renovated after thirty or forty years
Some torn down and turned into subdivided flats

That's the way we live
How I want to ask
The worker who put up the scaffolding
To leave these tiny neighbours alone
Even though they're different species
Before I utter a peep, the renovations are
 complete
The bird's nest remains, perched high
Kept safe

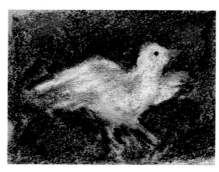

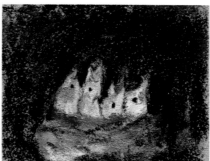

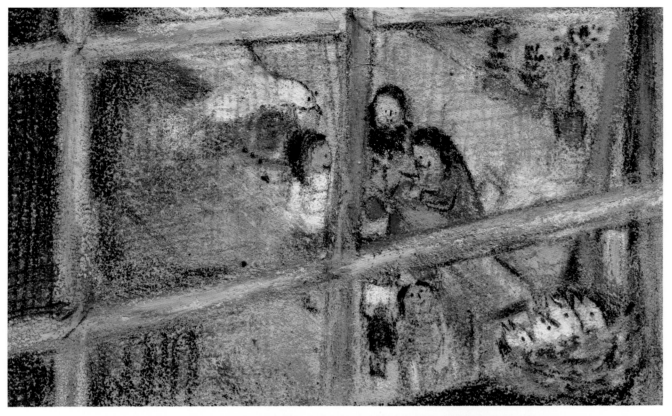

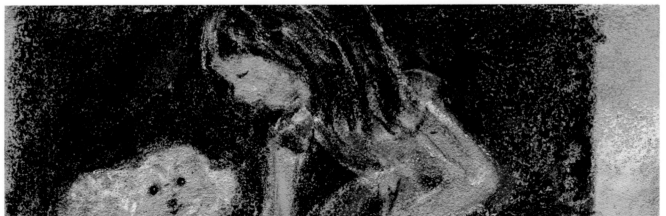

狒狒

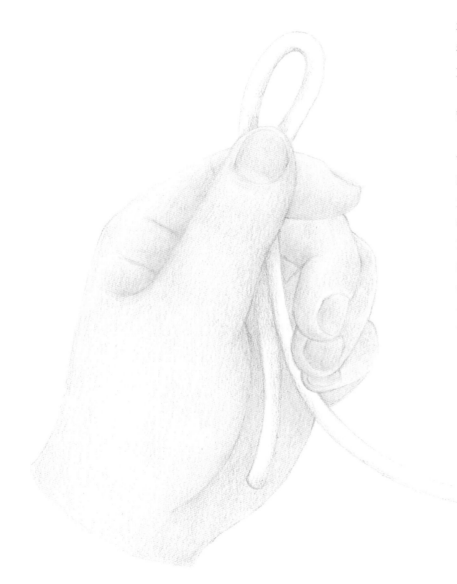

在日本名古屋動物園
我又見到了狒狒
大約有十多頭
由家長帶領
籠中還算潔淨安寧

當我走近觀看
虬鬚的大頭狒狒
立刻站起來歡迎
牠守在木箱旁邊
不斷向我擠眉弄眼
搖動手中一根粗繩
牠身邊的木箱
一段文字：
可和狒狒玩互動的遊戲

明白了，我拿起垂在籠外的
繩子，和狒狒拔河
對手是大塊頭
我呢，是小個子
才提起繩子
馬上扯了過去

拔不回來
木箱吐出一顆花生米
牠還叼在嘴裏，已經
熱切地示意我再來

狒狒啊
我多希望有足夠的力氣
把你拔出籠外
回到你生活的故鄉

At a zoo in Nagoya, Japan
I see the baboons once again
About a dozen of them
Led by the patriarch
The cage clean and peaceful

As soon as I come closer to take a look
A curly-bearded, big-headed baboon
Jumps up to welcome me
It keeps watch beside a wooden box
Winking at me nonstop
Shaking a thick rope in its hands
A string of text
On the wooden box next to it reads:
YOU CAN PLAY AN INTERACTIVE GAME WITH
 THE BABOONS

Understood. I pick up the rope hanging
Outside the cage, play tug-of-war with
 the baboon
My opponent a rather large fellow
Me, I'm the underdog
As soon as I lift the rope
It pulls it over at once
I can't tug it back
The wooden box spits out a peanut
The nut still in its mouth, it
Eagerly beckons me to come again

Oh baboon
How I wish I were strong enough
To tug you out of the cage
And return you to
 your homeland

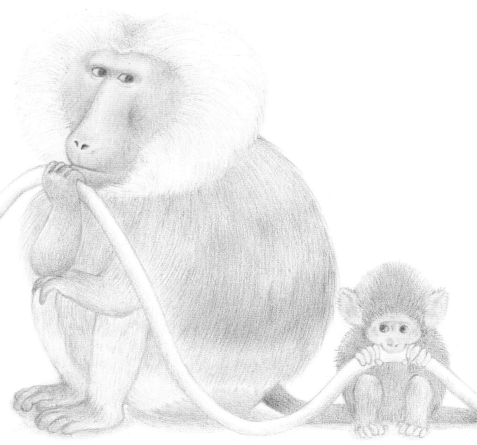

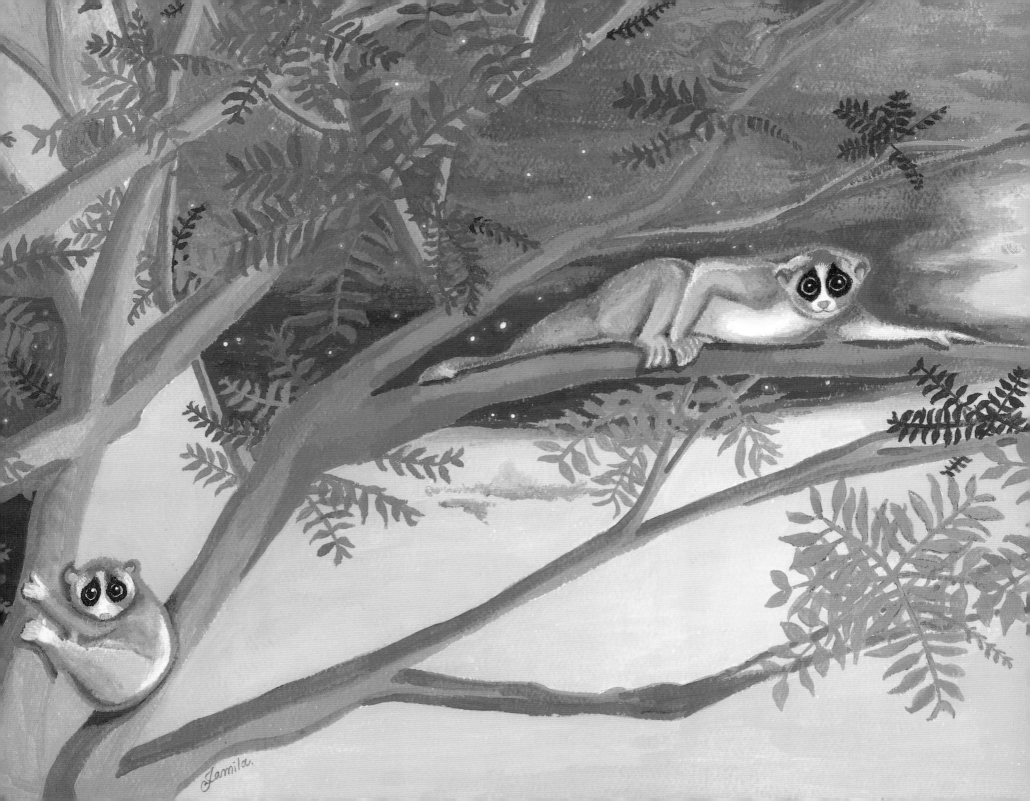

懶猴

懶先生看到動物奧運的競跑
牠的眼睛特大，不過才一眨眼
獵豹已經到了終點
把鴕鳥、黑羚全拋到老遠
到牠們抵達時
獵豹已經在樹下睡了好一覺
所以當人類跟牠挑戰長途
牠根本聽不到

懶先生可激動得幾乎從樹上摔下
牠一直不滿人類認為牠慢吞吞
是因為懶；又說牠腋下有毒
牠不斷抗辯：這是天生
牠於是決定也要練跑
訓練難道要等日子麼
牠開始從樹梢努力地爬下來
爬了整個上午
才爬到樹腰
正好日當頭
再花一個下午
才爬到樹腳
日頭漸落了

牠滿頭大汗
好像爬了個天長地久
夠了，明天再練吧

一年過去，日子快得像獵豹
牠果然爬得比其他懶猴快
早餐後不到午餐
就爬到了樹梢
這一天，牠的鄰居捲尾猴瞪着牠
老半天，問：
先生貴姓，剛搬來？
什麼，我是阿懶啊
別騙我，我的老友爬得很優雅
我們都羨慕牠；老哥
對不起，我不知道你像什麼？

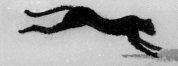

51

The Slow Loris

Mr. Slow watches an Animal Olympics race

His eyes are huge, but in just one blink

The cheetah reaches the finish line

Leaving the ostrich and blackbuck far behind

By the time they arrive

The cheetah has been enjoying a good sleep beneath the tree

So when humans challenge it to a long-distance race

It can't hear them at all

Mr. Slow is so excited he nearly falls off the tree

He's long resented that humans attribute his slowness

To laziness, or how they claim he has poison in his armpits

He constantly insists he was born this way

And so, he also decides to take up running

Who says training has to wait?

Giving his all, he starts climbing down from the treetop

Climbs all morning

To reach the tree trunk

Just in time for the midday sun

Then spends an afternoon

Climbing down to the foot of the tree

The sun sets

He sweats profusely

It's as though he's been climbing forever

That's enough, training will resume tomorrow

A year flies by, the days as fast as cheetahs

Sure enough, he can climb faster than other slow lorises

Between breakfast and lunch

He climbs up to the treetop

On this day, his neighbour the capuchin stares at him

For a long, long time, then asks:

Mister, what's your name—have you just moved in?

What? I'm Slowpoke

Don't lie to me, my old pal climbed gracefully

We all envied him; mate

Sorry, I don't know what you're supposed to be

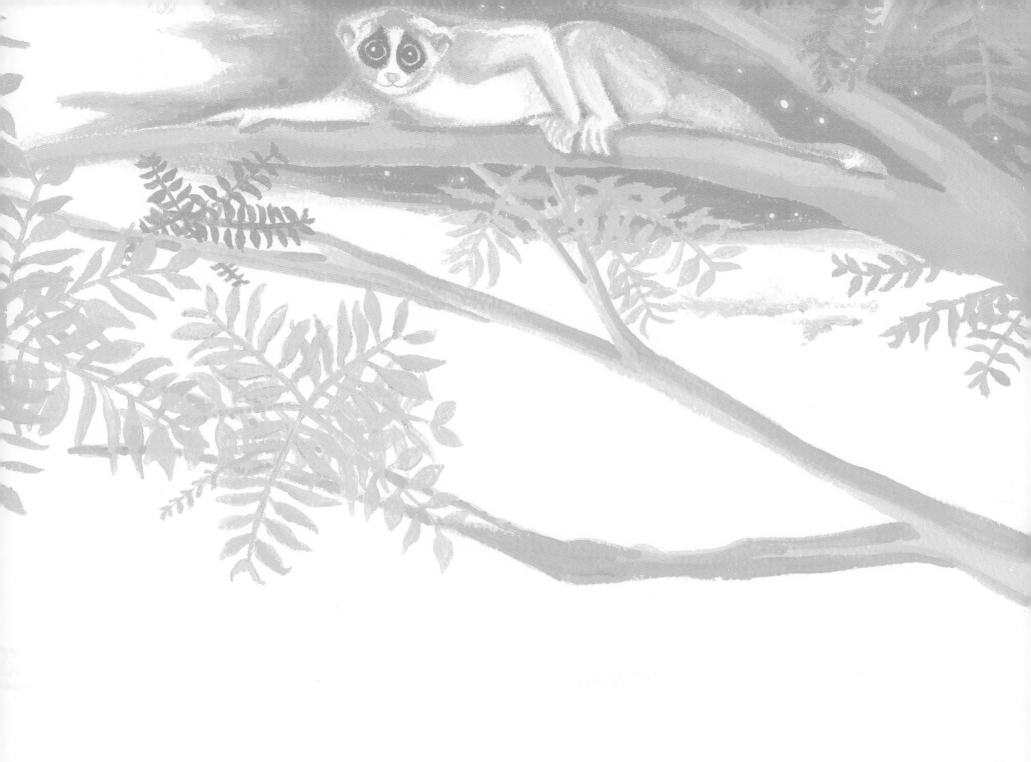

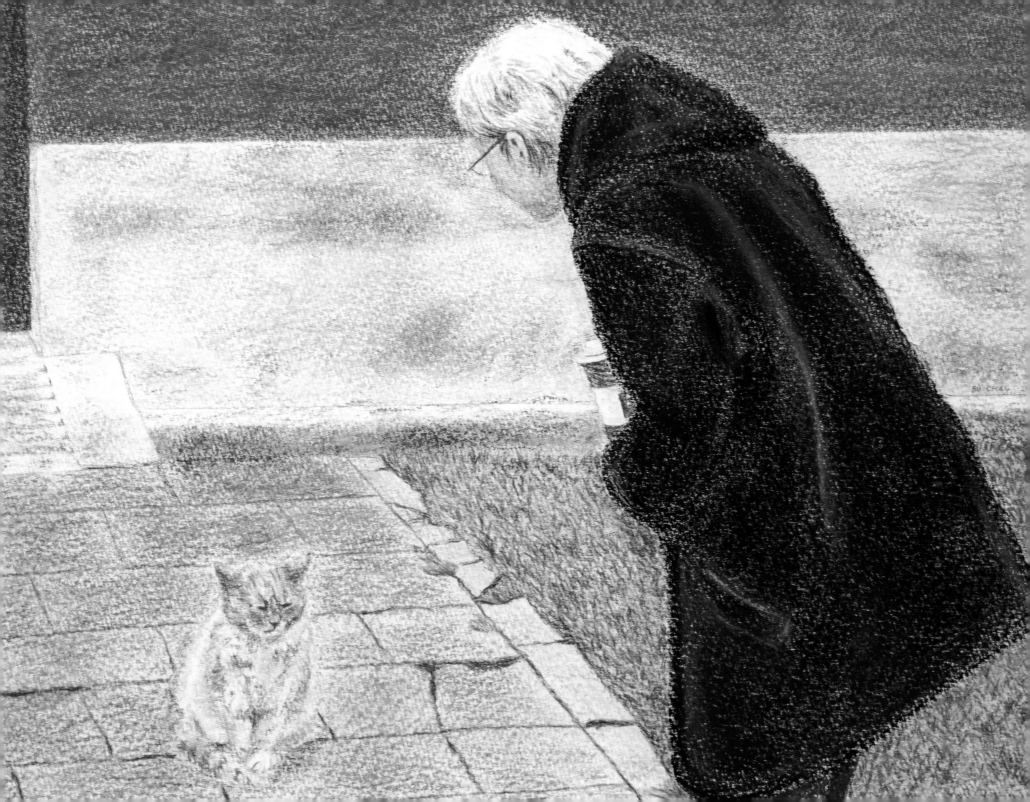

故宮貓保安

你好嗎？你好像
生病了
毛都鬆起來
眼睛朦朧
難得曬曬太陽
先伸伸懶腰
依偎一下我的腳
然後蹲坐着，不動
你是宮貓的後代還是
自己流浪到來
還不是一樣嗎
貴族和平民
看到你，就看到我自己
我們同樣經過年輕的日子
成為了長者，別問我
日子都溜到哪裏

你的一年，等於我五歲
你守護故宮
多少年了
鼠竊都不敢猖獗
牠們會破壞樑木
你不當是責任，很好
可十分重要呵
多麼希望我可以再來
再看到你，雖然
恐怕機會不大
我其實不知道能否再來
舟車太勞累
但我會記住這次邂逅
多麼美好的聚會
記住就夠了
我們互祝平安
珍重吧

The Forbidden City Security Guard Cat

How are you? You look
Sick
Fur all mussed up
Eyes hazy
Shying away from sunlight
First you stretch out
Nestle up against my feet
Then squat down, sitting still
Are you a descendant of a Forbidden
 City palace cat, or
A stray who's wandered over
Or aren't they one and the same
Nobility and commoners
Seeing you, I see myself
We've both passed through our
 youthful days
And now are seniors, don't ask me
Where the days slipped off to

One of your years equals five of mine
You've guarded the Forbidden City
For so many years
The rats dare not steal too much
They can destroy the beams
It's good you don't find it to be a
 burden
But it's an important job indeed
How I wish I could come again
See you again, although
I'm afraid there's little chance
I don't know if I can come back
The journey is too exhausting
But I'll remember this encounter
Such a lovely meeting
Just remembering it is enough
Let's wish each other well
Please take good care of yourself

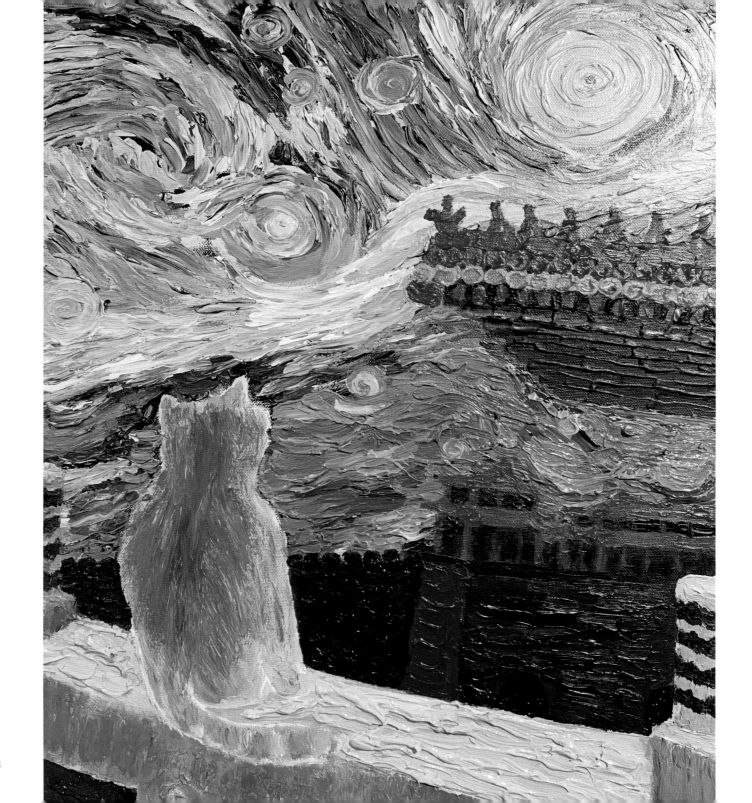

故宮貓看星

The Cat in the Forbidden City Gazes at Stars

還有哪裏比在故宮看星更好的位置？

遊客都走了

真是奇妙的世界

只有寧靜、平和的時候才能欣賞

要是打仗，許多次，啊

星圖就亂了

連星星也好像喪失光芒

所以，要是耗子不破壞樑木

大家其實可以和平相處

看那一顆顆閃亮的大眼睛

和我們對望

好像説了些什麼

又好像什麼也沒説

一直在看着我們

也許那其實是我們的祖先

離開後就上了上面

在暗中祝福我們

看着我們過自己的日子

What better place to stargaze than the Forbidden City?

The tourists have all gone

Such a wonderful world

That can only be appreciated when it's quiet and serene

If there are wars, and more wars, oh

The constellations will fall into disorder

Even the stars will seem to have lost their gleam

And so, if the rats don't destroy the beams

Everyone can live in peace

Look at those big shining eyes

Staring back at us

As though they're saying something

As though they're saying nothing

Watching us all along

Maybe they're actually our ancestors

After leaving, they ascend to the skies

Blessing us in secret

Watching as we live our lives

北極熊
The Polar Bear

我準備的冬衣
都很少穿
不是我不怕冷而是
天氣真的暖化了
冰川融解
像骨牌
電視上
看到一隻消瘦的北極熊
在冰塊的孤島上
旁邊還帶着一隻小小的熊仔
迷茫，失神
我把電視關去
天地不仁
我是否有太多的記掛
但暖化，難道不是人類
做成的嗎？我們
是一個個的孤島
互相推卸
對其他動物
卻在集體謀殺

The winter clothes I've prepared

I rarely wear

It's not that I'm not afraid of the cold but that

The weather is really warming up

Glaciers melting

Like dominos

On TV

I saw an emaciated polar bear

On an island of ice

A tiny bear cub beside it

Perplexed, spiritless

I shut off the TV

Nature isn't benevolent

Do I have too much on my mind?

But isn't warming human-

Made? We

Are lonely islands

Passing the blame to each other

While mass murdering

Other animals

金絲猴

The Golden Snub-Nosed Monkey

你的鼻子好像人們不成功的
　　整容
所有的僭建
都有下塌的風險
不過你是天生
下雨時到底有點麻煩
有時不得不低下頭
或者躲在大葉樹下
那一年我撐着傘子來看你
想到傘子
靈感可能從你們得來
你一身金黃，是否
又好像披金戴銀的人家
至於你的孩子呢
毛色是白色的
然後逐漸蛻變
那些喜歡炫耀的富二代
如果也能變變就好了
你的眼睛兩個大白圈
還有厚闊的嘴巴
我想到諧趣電影的主角
被蛇咬過，無意中

打通了經脈
功夫大進
展現健壯的手臂
保護自己的社區
我父親在上海，當年
也會和鄰居的叔伯們
拎着斧頭，去滅火
他們守望相助
可不是匪類
原來不對稱、古怪
可以有一種眩目的
美麗，有用
又有趣

Your nose looks like a botched plastic
　　surgery
All unauthorised construction
Runs the risk of collapse
But you were born this way
It's a bit of a hassle when it rains
Sometimes you have to bow your head
Or hide beneath big-leafed trees
The year I came to see you with an
　　umbrella in tow
I wondered if the inspiration for an
　　umbrella
Might've come from you all
Are you golden head to toe, or is it more
Like cloaked in gold, adorned in silver?
As for your kids
Their fur starts off white
Then transforms over time
Those rich second-generation show-offs
If only that could also change
Your eyes are two large white rings
And you have a thick, wide mouth

That reminds me of comedy films where
　　the protagonist
Is bitten by a snake, accidentally
Opening up blood vessels
Making great advancements in martial arts
Displaying strong arms
Protecting the community
When my father lived in Shanghai
He and neighbouring uncles
Used axes to put out fires
They looked out for each other
But weren't bandits
It turns out that things asymmetrical and
　　strange
Can have a dazzling
Beauty, be useful
And interesting

美麗的動物　　　　　　Beautiful Animals

動物界最近舉行選美會

大凡美麗、智慧、善良的動物都歡迎

不過可不接受偽裝

許多美麗的動物都來報名了

禿鷹除下了牠的假髮

鬣狗到河裏洗擦一番

露出身上好看的斑點

孔雀花枝招展地開屏

以為自己最漂亮，誰知

狐獴全都轉過頭去

不要以為美麗只有一種看法

蠑螈乘坐鸚鵡飛機

從老遠的墨西哥到來

花花對牠一見鍾情

不停喵喵地想跟牠搭訕

大家投票，終於選出了冠軍：

誕生了，一種可怕的美

那是來自馬達加斯加的

指猴

The animal kingdom recently held a beauty pageant

Welcoming those who were beautiful, intelligent, and kind

But putting on airs wasn't allowed

Many beautiful animals came and signed up

The bald eagle took off its wig

The hyena went to the river to scrub itself clean

Showing off its gorgeous spots

The peacock fanned out its brilliant feathers

Believing itself to be the prettiest, who'd have guessed

The meerkats would all turn their heads away

Don't assume there's only one view of beauty

The newt flew in on a parrot airplane

All the way from Mexico

Fa Fa fell in love with it at first sight

Meowing and meowing, trying to strike up a chat

Everyone cast their votes, and at last, a winner was crowned:

The emergence of a terrifying beauty

Hailing from Madagascar

The aye-aye

貓會生氣
—— 讀辛波絲卡〈空屋裏的貓〉有感

The Cat Would Be Angry
After Szymborska's "Cat in an Empty Apartment"

年紀越大	The older I get
越不敢養貓	The less I dare raise a cat
不是怕失去牠	It's not that I'm afraid of losing it
自己會傷心	I'd be heartbroken
而是怕	But I'm afraid
失去自己	It would lose me
牠會生氣	It would be angry
以為是	Thinking I'm the one
把牠拋棄了	Who abandoned it

動物嘉年華
Carnival of Animals

動物嘉年華

肥土鎮本來有一座動物園
後來關閉了
因為大家都反對把動物困在籠子裏
動物當然不斷抗議啦
但很少人聽得到
過了幾年
肥土鎮終於建了新的動物園
名字叫「圖像動物自由園」
動物都用木頭、毛海，或者布匹做成
有的是雕塑
有的是圖片

有的是文字
有的，讓觀眾發揮想像
並且製成3D動畫
園內沒有的，是籠子
動物都自由自在
因為是圖象
動物都不用戴口罩
都保證不受病毒感染

到動物園來的小朋友很多
花可久也來了

還帶了他的貓兒朋友花花一起來
一進園門
一群冕狐猴就跳着舞出來歡迎
看見粉紅色的羊駝
沿着環園大道走
樣子很諧趣
又看見檸檬色的松鼠
捲起比花花還要大的尾巴
淺藍色的兔子
兩隻大門牙忙碌極了
在吃着甘薯

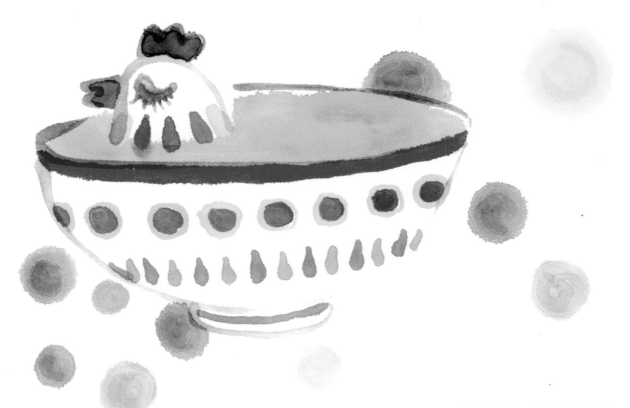

幾隻獵豹在練跑
只見黑色的斑點一閃一閃
轉眼不見了
還有紫色的大象
塊頭大，卻和氣安祥

花可久帶了照相機
給花花拍了很多照
咔嚓，花花和斑馬
咔嚓，花花和綿羊
咔嚓，花花和長頸鹿

這有點難度
只拍了花花和長頸鹿的腳
咔嚓，咔嚓，咔嚓
花花和獅子
花花和老虎
獅子和老虎難得聚首
也沒有吵架
咔嚓，花花和全家福的雪豹
企鵝左搖右擺的走來
說：「我是企鵝，我也想拍一張玩玩。」
花花和紅毛猩猩

猩猩掰開一個榴槤給花花
花花連打兩個噴嚏，說多謝

動物園內有許多涼亭
亭內有電視機
播放動物生活的紀錄片
一群禿鷹坐在長椅上
看得最入神
並且分吃爆玉米
竹絲雞一家大小在地上撿拾米碎

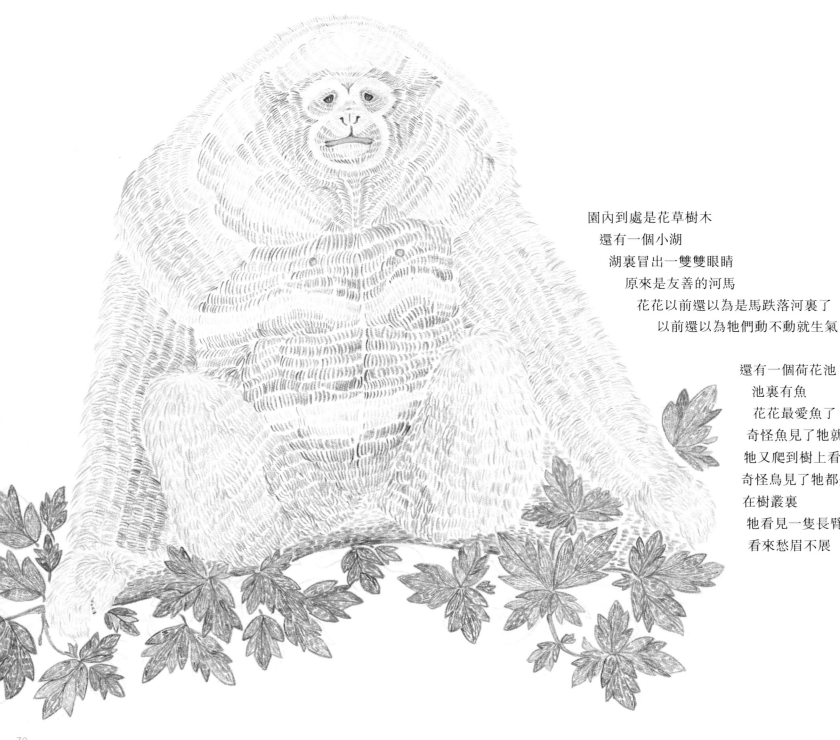

園內到處是花草樹木
還有一個小湖
湖裏冒出一雙雙眼睛
原來是友善的河馬
花花以前還以為是馬跌落河裏了
以前還以為牠們動不動就生氣

還有一個荷花池
池裏有魚
花花最愛魚了
奇怪魚見了牠就躲進荷花後面
牠又爬到樹上看鳥
奇怪鳥見了牠都飛走了
在樹叢裏
牠看見一隻長臂猿很胖
看來愁眉不展

「妙，你好嗎？我是花花。」
「……。」
「妙妙，你好嗎？」
「……。」
就是對牠愛理不理
不知是否嫌自己太胖
其實呢，只要健康
無論瘦或者胖也可以很好看

園內有一個公共意見區
讓動物發表意見
犀牛不會搶先
矮小的狐獴可以站在凳子上發言
全都受到尊重

不會排斥嗓門小
或者不同的意見
又可以不發表意見

園裏也舉行運動會
讓同類比賽，讓不同類表演
烏龜不會和兔子競跑
吼猴倒會和牛蛙合唱
牠們都會工作
但不會超過標準工時
夜間動物不會在日間亮相
日間動物夜裏不受打擾
獅大哥，虎大哥
都會放細聲浪

晚上升起一個個泡泡
有紅色、綠色、黃色、紫色……
原來是動物各種各樣的夢
花花的夢是什麼呢？
原來牠希望做足球員
守龍門，可以左右飛撲

園內還有不同年齡的退休保障
免費醫療服務
讓動物長者安享晚年
妙妙，我仍然在做夢麼？花花說
牠看見兩位長者在樹蔭下下棋
原來在玩和平動物棋

園內還有一座大樓
裏面有圖書館和創作室
大家都可以進去看書
用筆畫動物
用泥捏，用木刻
用布塊裁縫
或者寫各種真的或想像的動物故事
提示很溫馨：
這是動物嘉年華
作品不一定要用一個個文字
但請不要框框
不要籠子
好的作品，會留在館內展覽
參加創作的小朋友
都獲得入場券

參觀肥土鎮農場
樹木會說：我是高高的麵包樹
花會說：我是大紅花，生長在地上
不要以為我們不會思想
只不過頭腦在泥土裏
手腳在上面伸展

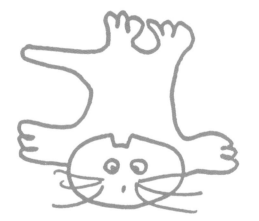

畫過畫的小朋友都會得獎
由圖像動物自由園贊助
乘船到肥土鎮的水域探訪白海豚
或者坐飛機到非洲去
參觀野生動物保護區
從一個地方到另一個地方旅行
可以打開眼界
結識不同的動物
花花也去創作啦
你看，牠畫得怎麼樣

Carnival of Animals

There used to be a zoo in Fertile Soil Town
Then it closed down
Because everyone was against keeping animals in cages
The animals protested, of course
But few people heard them
Several years passed
At last Fertile Soil Town built a new zoo
Called "Representations of Animals Freedom Park"
The animals are made of wood, mohair, or cloth
Some are sculptures
Some are pictures
Some are written words
Some invite the audience to use their imagination
And create 3D animations
What the zoo doesn't have are cages
All animals are free
Because they are representations
The animals don't need to wear masks
Everyone's guaranteed to be virus-free

Many young friends come to the zoo
Including Fa Evermore
Accompanied by his cat pal Fa Fa

As soon as they enter the zoo
A group of crowned lemurs welcomes them with a dance
They see a pink alpaca
Strolling along Ring Park Avenue
Looking very funny
They also spot a lemon-coloured squirrel
Curling up its tail that's bigger than Fa Fa
A light blue rabbit
With two extremely busy front teeth
Chowing down on sweet potatoes
Cheetahs practicing running
They can only make out twinkling flecks of black
Gone in the blink of an eye
There's a purple elephant as well
Large in size, but serene

Fa Evermore brings a camera
Snaps photo after photo of Fa Fa
Click—Fa Fa and a zebra
Click—Fa Fa and a sheep
Click—Fa Fa and a giraffe
This proves a tad challenging
He only captures Fa Fa and the giraffe's feet
Click, click, click
Fa Fa and a lion
Fa Fa and a tiger
Lions and tigers rarely gather together
And what's more, nobody fights
Click—Fa Fa and a family of snow leopards
A penguin waddles from side to side
Says: "I'm a penguin. I wanna take a picture too."
Fa Fa and an orangutan
The orangutan breaks open a durian and
 gives it to Fa Fa
Fa Fa sneezes twice—achoo!—and says thank you

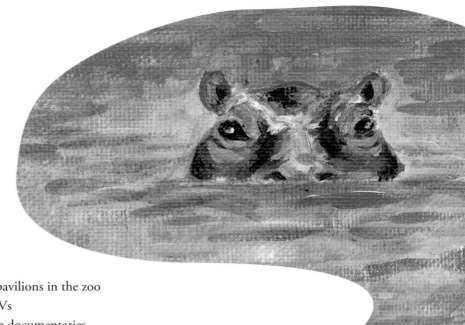

There are several pavilions in the zoo
Inside there are TVs
Playing animal life documentaries
A committee of vultures sits on a bench
Deeply entranced
And sharing popcorn
A family of black silkie chickens picks up bits of rice
 on the ground

The zoo teems with flowers and trees
There's a small lake too
Eyes surface from the lake
Friendly hippos
Fa Fa used to think hippopotamuses were moose
 that had fallen into a pot
And that they were quick to lose their tempers

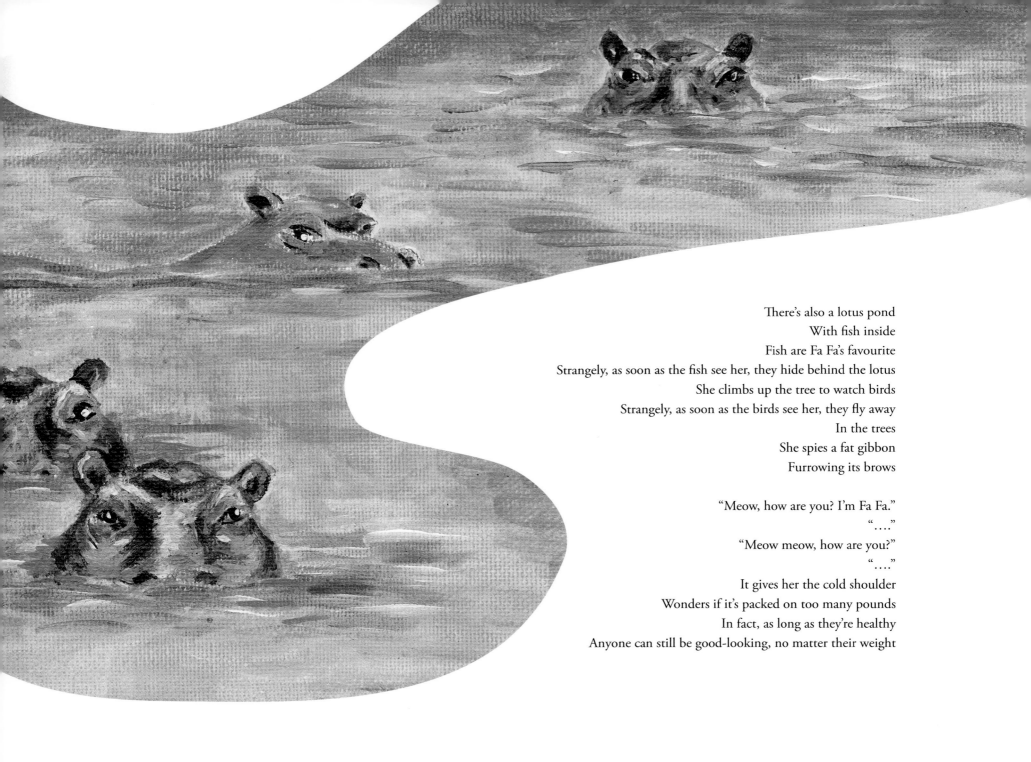

There's also a lotus pond
With fish inside
Fish are Fa Fa's favourite
Strangely, as soon as the fish see her, they hide behind the lotus
She climbs up the tree to watch birds
Strangely, as soon as the birds see her, they fly away
In the trees
She spies a fat gibbon
Furrowing its brows

"Meow, how are you? I'm Fa Fa."
"…."
"Meow meow, how are you?"
"…."
It gives her the cold shoulder
Wonders if it's packed on too many pounds
In fact, as long as they're healthy
Anyone can still be good-looking, no matter their weight

The zoo has a public opinion area
For animals to express their opinions
The rhinoceros won't strive to be the first
The dwarf meerkat can stand on a stool to
 deliver its speech
All are respected
Smaller voices won't be rejected
Nor will differing opinions
Making no comment is also acceptable

The zoo holds sports meets too
Allowing those of the same species to compete,
 those of different species to perform
Tortoises won't race with hares
Howler monkeys can sing with bullfrogs
Everyone has a job
But no one works overtime
Nocturnal animals don't appear during the day
Daytime animals aren't disturbed after dark
Big Brother Lion and Big Brother Tiger

Speak in hushed tones
Bubbles rise at night
Red, green, yellow, purple …
They're all kinds of animal dreams
What's Fa Fa's dream?
She wants to be a football player
A goalkeeper to be precise, flying left and right

The zoo also offers retirement benefits at different ages
Free medical treatment
So that the animals can enjoy their golden years
Meow meow, am I still dreaming? Fa Fa says
She sees two senior citizens playing chess in the shade
The game is Non-Violent Animal Chess

There's also a storied building in the zoo
With a library and a creative studio
Everyone can go in and read books
Draw animals with a pen or pencil
Knead clay, carve wood
Cut and sew cloth
Or write all sorts of real or imaginary animal tales
The prompts are soft and sweet:
This is a carnival of animals
Creative works needn't use a single word
But no boxes please
No cages
Great works will stay on display in the museum
Young friends who participate in the creation
Will receive free admission
To visit Fertile Soil Town Farm
The trees will say: I'm a tall breadfruit tree

The flowers will say: I'm a big red flower, growing from
 the ground
Don't assume we cannot think
It's merely that our heads are in the dirt
Hands and feet stretched up above

Young friends who draw pictures will all win awards
Sponsored by the Representations of Animals Freedom Park
Take a boat trip to the waters of Fertile Soil Town to visit
 white dolphins
Or fly on a plane to Africa
To explore a wildlife reserve
Travelling from one place to another
Can be eye-opening
Getting to know different animals
Fa Fa also decides to create something
Take a look, see how she draws

Translator's Notes

The Alpaca

In this poem, Xi Xi plays with the Chinese word for alpaca, 羊駝, which literally means "sheep-camel," inverting the name as 駝羊, or "camel-sheep." To recreate her wordplay in English, I literally translate these words as "sheepish camel" and "camelish sheep." Additionally, I similarly play with the animal's scientific name, lama pacos: after "camelish sheep," I add the inverted scientific name, "pacos lama," in parenthesis, switching to "lama pacos" after "sheepish camel." Later in the poem, she mentions that the alpaca is also known as the 草泥馬, literally "grass mud horse," which is a near-homophone for a curse word involving one's mother. I translate this first as "muddy llama" to chime off of "lama pacos," followed by "bloody mama" in parenthesis to evoke the curse word.

Xi Xi also plays with the word for panda, 熊貓, literally "bear-cat," by inverting it as 貓熊 "cat-bear." In bringing this instance of wordplay into English, I have translated "cat-bear" as "panda cat" and "bear-cat" as "panda bear."

The Jellyfish and the Slug

This poem alludes to "The Medusa and the Snail," an essay by American science writer Lewis Thomas that explores the symbiotic relationship between the nudibranch sea slug and the medusa of a jellyfish in the Bay of Naples.

My Friend's Cat

This short poem hinges on a pun based on the verb 讀破, which means to read thoroughly or extensively, but literally means to read to the point of destruction.

Carnival of Animals

Fertile Soil Town 肥土鎮 is a fictional stand-in for Hong Kong that appears in several of Xi Xi's works, including her novel *Flying Carpet* and short fiction "The Story of Fertile Soil Town," "Apple," "Town Curse," "The Fertile Soil Town Chalk Circle" and "An Addendum to *Cosmicomics*."

The child mentioned in the poem, 花可久, is a character from *Flying Carpet* and "The Story of Fertile Soil Town." I have translated the name here as Fa Evermore to highlight the whimsy of the poem, and also to create a pun on the expression "forever more." The cat's name, Fa Fa, literally means "flower flower."

The Chinese word for hippopotamus, 河馬, literally means "river horse." Xi Xi plays with this literal meaning in a line that reads "Fa Fa used to think hippopotamuses were horses that had fallen into a river." I recreate this wordplay in English by rendering the line as "Fa Fa used to think hippopotamuses were moose that had fallen into a pot."

插畫師簡介（按出場次序）
Illustrators' Bios (In order of appearance)

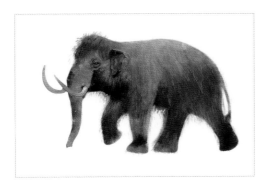

余穎欣的作品涵蓋視覺藝術、實驗動畫、影像及聲音。她關注作品中創作者和經驗者之間的關係。她相信由藝術所誘發的多重感受能揭示日常生活難以言明的真實面。近日，她花多了時間在閱讀關於疫症、食物和香港歷史的書籍。

Yu Wing-yan is a multi-talented media artist. Her wide range of works encompasses various artistic mediums, including illustration, animation, videography, and sound. She is concerned with the interrelation between the arts, its creators, and its audience, and believes that art can portray the indescribable realities of daily life. Recently, she has been spending more time reading books about pandemics, food, and Hong Kong history.

yuwingyan.com

余穎欣，《失去猛獁象的語言》，2022，數碼繪圖，21 x 29.7 cm
Yu Wing-yan, *The Lost Language of the Mammoth*, 2022, digital art, 21 x 29.7 cm

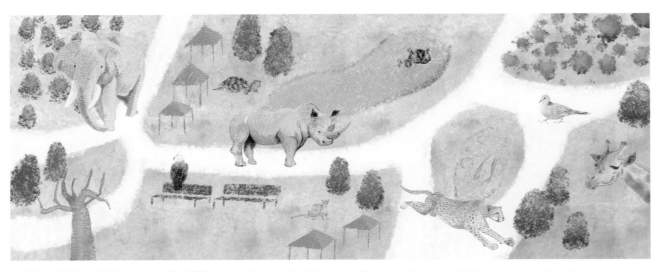

余穎欣，《動物嘉年華》，2022，數碼繪圖，21 x 56 cm　Yu Wing-yan, *Carnival of Animals*, 2022, digital art, 21 x 56 cm

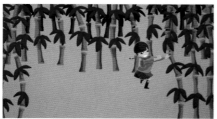

梁敏琪，《大公雞》，2015，數碼繪圖，
36 x 65 cm
Flora Leung, *The Large Rooster*,
2015, digital art, 36 x 65 cm

梁敏琪，《女孩》，2015，數碼繪圖，
36 x 65 cm
Flora Leung, *Girl*, 2015, digital art,
36 x 65 cm

梁敏琪，香港人，曾於本地動畫公司
工作，其後開始自行創作動畫及畫作。
Flora Leung is a Hongkonger who previously
worked for a local animation company.
Currently, she independently creates her own
animations and paintings.

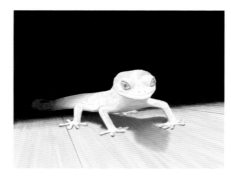

Jungyip，《壁虎》，2022，數碼繪圖，
22 x 28 cm
Jungyip, *The Gecko*, 2022, digital art,
22 x 28 cm

Jungyip攝影學系畢業，喜歡以繪畫代
替文字和說話，表達有趣意念和美麗
瞬間。不定期在網絡上發佈作品。

Jungyip holds a bachelor's degree in
photography. He would rather paint than use
words to express funny ideas and beautiful
moments. He often posts his works online.

Instagram@jungyip

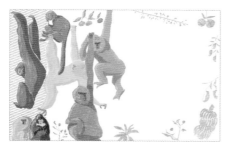

林建才，《長臂猿》，2022，獨幅版畫
及數碼拼貼，30 x 43 cm
Kinchoi Lam, *The Gibbon*, 2022,
monotype and digital collage,
30 x 43 cm

林建才為香港藝術家，創作媒介包括
繪畫、 版畫及繪本。 他2012年畢業
於香港城市大學創意媒體學院，並於
2020年在 Anglia Ruskin University 取得兒童書插畫碩士學位。林氏喜歡走路，作品常
常啟發自日常生活及路上的觀察。

Kinchoi Lam (b. 1988) is an artist, picture book creator, and printmaker based in Hong Kong. Lam
received his Bachelor of Arts from the School of Creative Media at the City University of Hong
Kong in 2012, and his Master of Children's Book Illustration from Anglia Ruskin University in
2020. His art mainly focuses on the pursuit and discovery of the wonders of daily life.

lamkinchoi.com

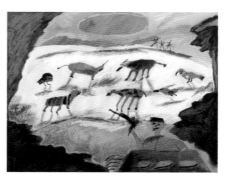

胡愷昕，《可怕的動物》，2022，水粉、
木顏色、鉛筆紙本，21 x 26.7 cm
Glary Wu, *Scary Animals*, 2022,
gouache, coloured pencil, and pencil
on paper, 21 x 26.7 cm

胡愷昕，香港畫家，2019年畢業於香
港浸會大學視覺藝術院。擅長以作品
為語言，連結自身與社會。她以日常
生活中最容易忽視的細節作為靈感，
並融合小說家、社會學家，甚至是陌
生人和鏡頭下的人物，擦出不同領域之間的火花。2021年舉辦個展「Flower Speaks」。
曾參與的展覽包括「無用之用」(2021年)、柏林的「IAM international art moves」展(2020
年)、「Unfolded@PMQ」展(2019年)等。

Glary Wu (b. 1996) is a Hong Kong artist. She graduated with a BA in Visual Arts (Hons) from
the Academy of Visual Arts at Hong Kong Baptist University in 2019. Wu's work transforms and
defamiliarises ordinary things through painting and drawing. They are based on her observations
on things minor and inconspicuous, infused with references from novelists, photographs she has
taken, and strangers she has met in her daily life. She has participated in the solo exhibition "Flowers
Speak" (Infectment, Hong Kong, 2021) and the group exhibitions "The Use of The Useless"
(PMQ, Hong Kong, 2021) and "IAM international art moves" (Pathfinder, Berlin, 2020).

wuhoiyanglary.com

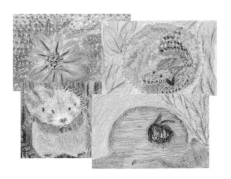

王碧蔚，《想像的動物》，2022，油粉彩、乾粉彩及馬克筆紙本，22 x 28 cm
Wong Pik-wai, *The Imaginary Animal*, 2022, oil pastel, dry pastel, and marker pen on paper, 22 x 28 cm

王碧蔚，1999年生於香港，中大中文系。曾獲孔梁巧玲文學獎、中文文學創作獎、青年文學獎等。作品散見於《字花》及網站別字、虛詞。

Wong Pik-wai was born in 1999 and received her Bachelor of Arts in Chinese from the Chinse University of Hong Kong. She is the winner of the 3rd Hung Leung Hau Ling Young Writer Award, Award for Creative Writing in Chinese, and Youth Literary Award. Her works can be found in the literary magazine *Fleurs des Lettres* and the websites Bie Zi and p-articles.

Instagram@wongpikwai

高立，《牠住在五星級酒店》，2022，塑膠彩布本，86 x 111 cm
Ko Lap, *It Lives in a Five-Star Hotel*, 2022, acrylic on canvas, 86 x 111 cm

高立喜歡以畫說話，取代語言。近年開始實驗用畫跟文學進行對話。作品在《明報》「星期日生活」發表，欄目「十二因緣」邀請了66位香港文學作家，在文字和繪畫的對話中回應時代，最後結集成《黑暗夜空擦亮暗黑隕石》一書並舉辦同名展覽。

Ko Lap believes "a painting is a poem without words." His column "Twelve Nidānas" in *Sunday Mingpao* is an experiment that engages 66 Hong Kong authors in conversation with his artwork. The column is a literary and visual response to our time and is being developed into a book and an exhibition titled *Black Meteorites Brightened in Dark Sky*.

Instagram@lap.ko

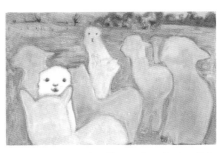

江俊雅，《羊駝》，2022，木顏色及塑膠彩紙本，11.5 x 17.6 cm
Kong Chun-nga, *The Alpaca*, 2022, coloured pencil and acrylic on paper, 11.5 x 17.6 cm

江俊雅生於香港。她於2017年畢業於墨爾本皇家理工大學與香港藝術學院合辦之藝術文學士課程，並於2020年於香港中文大學獲得英國文學研究碩士學位。她以繪畫摘錄生活日常中的點滴絮語；她用寫作去懷念各樣感受，透過日記去記錄、虛構一篇又一篇的小説故事。

Kong Chun-nga (Kitty) is based in Hong Kong. She obtained her Bachelor of Arts (Fine Art) at Royal Melbourne Institute of Technology University (co-presented by Hong Kong Art School) in 2017 and an MA in English (Literary Studies) at the Chinese University of Hong Kong in 2020. Her paintings reflect the way she moves through fragmented everyday life; her writing is structured as a means of commemoration, although her diary is viewed by many people as general fiction.

kongchunnga.com

蔡佳美，《什麼也不是的動物》，2022，針筆、木顏色筆及蠟筆紙本，25 x 28 cm
Tsoi Kai-mei, *The Animal That Wasn't Anything*, 2022, technical pen, coloured pencil, and crayon on paper, 25 x 28 cm

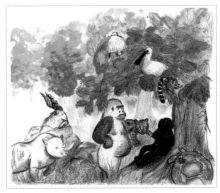

蔡佳美
「我愛貓，所以愛畫貓。」
Tsoi Kai-mei
"I love my stupid cats, so I draw them."

Instagram@tatalailai1116

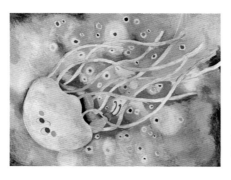

吳淑燕、吳淑媚，《水母與蛞蝓》，
2022，油粉彩紙本，55 x 80 cm

Hazel Ng Shuk-yin and Heather Ng
Shuk-mei, *The Jellyfish and the Slug*,
2022, oil pastel on paper, 55 x 80 cm

兩人一狗，隱居於藍田碧雲。正業餵
養小狗，副業繪畫。熱愛正業，是一
對不務副業的閒雲野鶴。

Hazel, Heather, and their doggo are flâneurs who've wandered away from urban city life. Raising their dog is their profession, and they are amateurs at painting and drawing. Perhaps they are slightly more passionate about their lovely hair master than their mediocre art-making.

Instagram@contemporary_rurallife

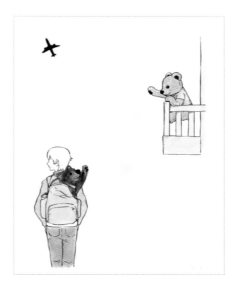

黎特，《熊出遊》，2022，數碼繪圖，
28 x 22 cm
Joseph Knight, *A Bear Goes Travelling*,
2022, digital art, 28 x 22 cm

黎特，香港漫畫家、插畫家、影片製
作人、文字作家、填詞人、電台主
持。自稱周身刀無張利，勉強在文化
界生存下來的四不像。

Joseph Knight is a Hong Kong cartoonist, illustrator, video creator, writer, lyricist, and radio host. He declares himself Jack of all trades, master of none. Neither fish nor fowl and barely survived in the creative industry.

Instagram@knightlaiart

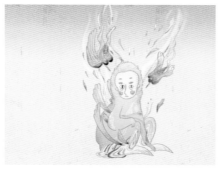

林穎詩，《我不和你比》，2022，電子
繪圖，22 x 28 cm
Sissy Lam, *I Won't Compete with You*,
2022, digital art, 22 x 28 cm

林穎詩，插畫師，畢業於嶺南大學文
化研究系。常以日常生活題材轉換到
魔幻的想像世界中創作，創作媒介多
為水彩畫及手繪風電繪，喜愛創作繪
本。無論有沒有被看見，每個人也擁
有一顆赤子之心。

Sissy Lam is an illustrator who graduated from the Department of Cultural Studies at Lingnan University. She observes daily life and transforms it into magical and surreal worlds through her art. Her main mediums are watercolour and hand-drawn digital painting. She has a passion for creating picture books. No matter if we are seen or not, everyone's innocence should be preserved.

Instagram@sissylamart

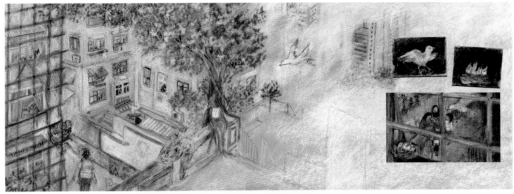

貓珊，《暖巢》，2022，蠟筆及木顏色粉卡，22 x 56 cm
Maoshan Connie, *Warm Nest*, 2022, crayon and coloured pencil on pastel card, 22 x 56 cm

貓珊，全職地圖及兒童書的作者和繪者。大學時期主修建築，其後於劍橋大學修讀兒童文學。繪畫工作以外，亦於動物慈善機構當義工多年。現生活於香港。平日可以在大海中或者書店的大樹下找到她。

Maoshan Connie lives and works in Hong Kong. She makes picture books, illustrates maps, and writes to trees. You can find her sometimes swimming in the sea, or sitting under a tree outside of a bookstore, illustrating.

Instagram@maoshanconnie

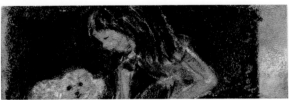

高曉君，《狒狒》，2022，木顏色紙本，21 x 59.4 cm，29.7 x 42 cm
Ko Hiu-kwan, *The Baboon*, 2022, coloured pencil on paper, 21 x 59.4 cm, 29.7 x 42 cm

高曉君，現為視藝教育工作者，喜歡進行不同類型的視藝創作，如繪畫、版畫及立體創作。

Ko Hiu-kwan is currently a visual arts educator. She enjoys engaging in various artistic mediums, such as drawing, printmaking, and 3D modelling.

Instagram@hkko_art

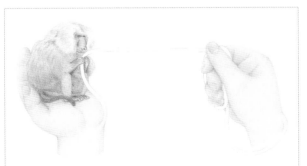

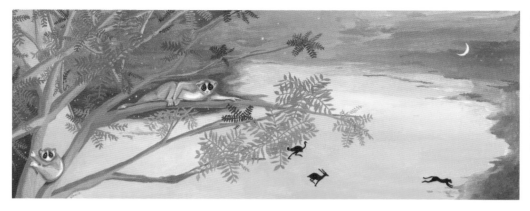

Jamila mushroom，《懶猴》，2022，塑膠彩及水粉紙本，22 x 56 cm
Jamila mushroom, *The Slow Loris*, 2022, acrylic and gouache on paper, 22 x 56 cm

Jamila mushroom 畢業於香港中文大學，取得藝術系學士及哲學系文學碩士。她的作品靜謐空靈。

Jamila mushroom graduated with a Bachelor of Fine Arts and Master of Arts in Philosophy from the Chinese University of Hong Kong. Her drawings embrace tranquility and lightness.

Instagram@jamila_mushroom_drawing

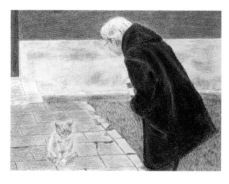

陳煲，《故宮貓保安》，2022，乾粉彩及木顏色紙本，22 x 28 cm
Bo Chan, *The Forbidden City Security Guard Cat*, 2022, dry pastel and coloured pencil on paper, 22 x 28 cm

陳煲，畢業於浸大中文系，現從事香港文學相關工作。全職工作後開始習畫，喜歡粉彩、木顏色與動物。

Bo Chan graduated from the Department of Chinese at Hong Kong Baptist University. She started painting after obtaining a job related to Hong Kong literature. She loves animals, as well as painting with pastels and coloured pencils.

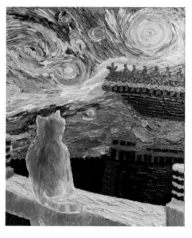

岑智明，《故宮貓看星》，2022，塑膠彩布本，51 x 40.5cm
Shun Chi-ming, *The Cat in the Forbidden City Gazes at Stars*, 2022, acrylic on canvas, 51 x 40.5 cm

岑智明，畢業於香港大學，獲理學士，主修物理。1986年加入香港天文台為科學主任，2011年晉升香港天文台台長，2020年退休。岑先生開發了全球第一套激光雷達風切變預警系統，並於2010–2018年擔任世界氣象組織航空氣象學委員會主席。

Shun Chi-ming graduated from the University of Hong Kong, where he obtained a Bachelor of Science in Physics. Mr. Shun joined the Hong Kong Observatory as Scientific Officer in 1986. He was promoted to Director of the Hong Kong Observatory in 2011 and retired in 2020. Mr. Shun developed the world-first Light Detection and Ranging Windshear Alerting System and was the President of the Commission for Aeronautical Meteorology of the World Meteorological Organization from 2010–2018.

cmshun.hk

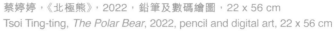

蔡婷婷,《北極熊》, 2022, 鉛筆及數碼繪圖, 22 x 56 cm
Tsoi Ting-ting, *The Polar Bear*, 2022, pencil and digital art, 22 x 56 cm

蔡婷婷,《仙樂飄飄聞啼鳥》, 2022, 鉛筆及數碼繪圖, 8 x 15 cm
Tsoi Ting-ting, *Let's Bird and Roll*, 2022, pencil and digital art, 8 x 15 cm

蔡婷婷, 90後的新界牛, 從事出版社的書籍排版及裝幀設計, 希望能畫出看起來有一點點開心的作品, 特別喜歡為身邊的物件和動物配上有趣又可愛的神態。因為太愛吃粟米而創作了漫畫人物「粟米六粒」一家。

Tsoi Ting-ting is a New Territorries bumpkin born in the 1990s who works in book production and book design. She hopes her works can make people smile, and is especially fond of drawing funny and cute faces on objects and animals around her. She loves eating corn so much that she created the family of comic characters Six Kernels of Corn.

Instagram@corn_ssssss

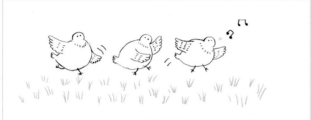

Roughmoon,《金絲猴》, 2022, 數碼繪圖, 21 x 56 cm
Roughmoon, *The Golden Snub-Nosed Monkey*, 2022, digital art, 21 x 56 cm

Roughmoon。80後。成長於香港, 現居英國。喜歡散步和聊天。

Roughmoon was born in the 80s. She grew up in Hong Kong, and now resides in the UK. She likes strolling and chatting.

Instagram@roughmoon_forest

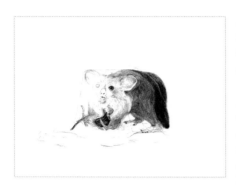

三三，《美麗的動物》，2022，鉛筆及
木顏色筆紙本，22 x 28 cm
Sansan, *Beautiful Animals*, 2022, pencil
and coloured pencil on paper, 22 x 28 cm

三三，從原名的「慧」字擦剩六橫劃，
便是三三。寫書法的設計師，為人即
興。小時愛讀《牛仔》漫畫，學畫沒
天份，卻因而畫出自在。從前多愁善
感，其後一路學習溫柔而靈巧。眈天
望地，愛與書和音樂作伴，筆劃線條
成生活的詩意。

Sansan looks into her real Chinese name and removes several strokes and dots from the character; what remains is this artist name that she gives herself. Being a graphic designer, Sansan writes calligraphy and draws without formal training, while learning to live gently and tenderly/wholeheartedly.

Instagram@lightime_blossoming

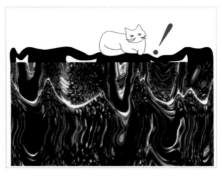

劉掬色，《貓會生氣》，2022，數碼打
印——組裝的拼貼與繪圖（貓出自西西
之手），22 x 28 cm
Gukzik Lau, *The Cat Would Be Angry*,
2022, digital print——combination of
drawing and collage (Cat by Xi Xi),
22 x 28 cm

劉掬色，香港出生，中小學在港讀書，
後在外學習視藝，藉文字加圖畫創作
認識自己，覺悟藝術是個認識自己的
過程，從中得以認識世界，明白愛世界等於愛自己。曾多年從事視藝教育，喜歡「駁
嘴」學生，往後都成為長久的朋友。

Gukzik Lau was born in Hong Kong, where she received her primary and secondary education before furthering her studies in visual arts abroad. Gukzik has found creative activities in both writing and artwork production to be truly enlightening. She has come to realise that art is what makes her gain insight into her true self as well as the true nature of the world, and to have love for our world is to love ourselves. As a visual arts educator for years, Gukzik has always welcomed students who challenge her in any way, developing long-lasting friendships with them.

gukzik.wixsite.com/gukziklau

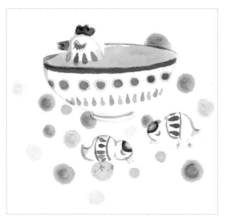

陳麗娟，《竹絲雞》，2022，水墨設色
紙本，35 x 35 cm
Chan Lai-kuen, *Black Silkie Chickens*,
2022, ink and pigment on rice paper,
35 x 35 cm

陳麗娟於香港出生及成長，著有詩集
《有貓在歌唱》(2010) 及散文集《不能
抵達的京都》(2015)。《有貓在歌唱》
獲香港中文文學雙年獎推薦獎。陳氏
於 2019 年赴美國愛荷華大學參與國際
寫作計劃，現就讀於國立臺北藝術大
學文學跨域創作研究所。

Chan Lai-kuen was born and raised in Hong Kong. Her book of poetry *Cats Were Singing* (2010) was awarded Recommendation Prize of the 11th Hong Kong Biennial Awards for Chinese Literature. Her prose collection *The Kyoto That Cannot Be Reached* was published in 2015. Chan was invited to participate in the International Writing Program Fall Residency at the University of Iowa in 2019. She is now pursuing an MFA in creative writing at the Taipei National University of the Arts.

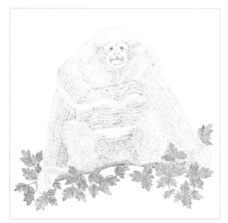

黃怡，《長臂猿》，2022，木顏色紙本，
39 x 27 cm
Wong Yi, *The Gibbon*, 2022, coloured
pencil on paper, 39 x 27 cm

黃怡，香港作家，香港電台《開卷樂》
主持，《字花》編輯。著有小說集《據報
有人寫小說》、《補丁之家》、《林葉的
四季》、《擠迫之城的戀愛方法》；曾改
編西西短篇小說〈感冒〉及〈像我這樣的
一個女子〉為粵語室內歌劇《兩個女子》
文本，於 2021 年香港藝術節首演。

Wong Yi is a Hong Kong writer, host of Radio Television Hong Kong's radio show *Book Review*, and editor at *Fleurs des lettres*. She is the author of four collections of short stories: *News Stories*; *Patched Up*; *The Four Seasons of Lam Yip*; and *Ways to Love in a Crowded City*. She is also the librettist of the Cantonese-language chamber opera *Women Like Us* (commissioned and produced by the Hong Kong Arts Festival and premiered in 2021), which is adapted from Xi Xi's short stories "The Cold" and "A Girl Like Me."

Instagram@wongyiwrites

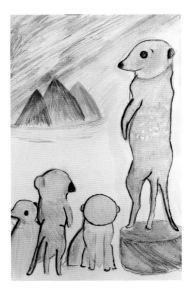

王爾心，《狐獴》，2022，木顏色紙本，
30 x 20 cm
Wong Yi-sum, *Meerkats*, 2022,
coloured pencil on paper, 30 x 20 cm

王爾心，十二歲，從小對表演藝術有濃厚的興
趣，也喜歡繪畫及書法，跟從不同老師學習繪
畫。

Wong Yi-sum is 12 years old and is deeply interested
in the performing arts. She also loves painting and
calligraphy and is studying under the guidance of
various art teachers.

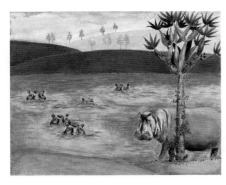

謝曉虹，《河馬》，2022，塑膠彩布
本，40.6 x 50.8 cm
Dorothy Tse, *Hippos*, 2022, acrylic on
canvas, 40.6 x 50.8 cm

謝曉虹，著有《好黑》、《鷹頭貓與音樂
箱女孩》、《無遮鬼》等，編有《香港文
學大系1919–1949：小說卷一》。《字花》
雜誌發起人之一。現任教於香港浸會
大學人文及創作系。

Dorothy Tse is a Hong Kong writer. Her
first novel *Owlish* (translated by Natascha Bruce) will be published in English in 2023 by
Graywolf Press in the US and Fitzcarraldo Editions in the UK. She teaches creative writing at
Hong Kong Baptist University.

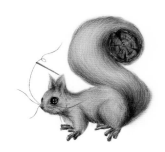

Kylie Lau，《松鼠》，2022，針筆及木
顏色紙本，21 x 29.7 cm
Kylie Lau, *The Squirrel*, 2022,
technical pen and coloured pencil on
paper, 21 x 29.7 cm

Kylie Lau，藝術系學生，繪畫關於自
然、動物與夢。

Kylie Lau is an art student who specialises
in scenic art. She draws nature, animals,
and dreams.

okyliela.art.blog

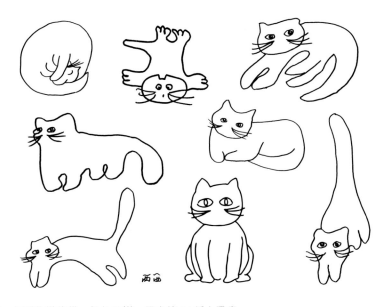

西西，各種各樣的貓，年份不詳，黑水筆 A4 紙上亂畫
Xi Xi, various cats, n.d., ink scribbling on A4 paper